VELOCITY

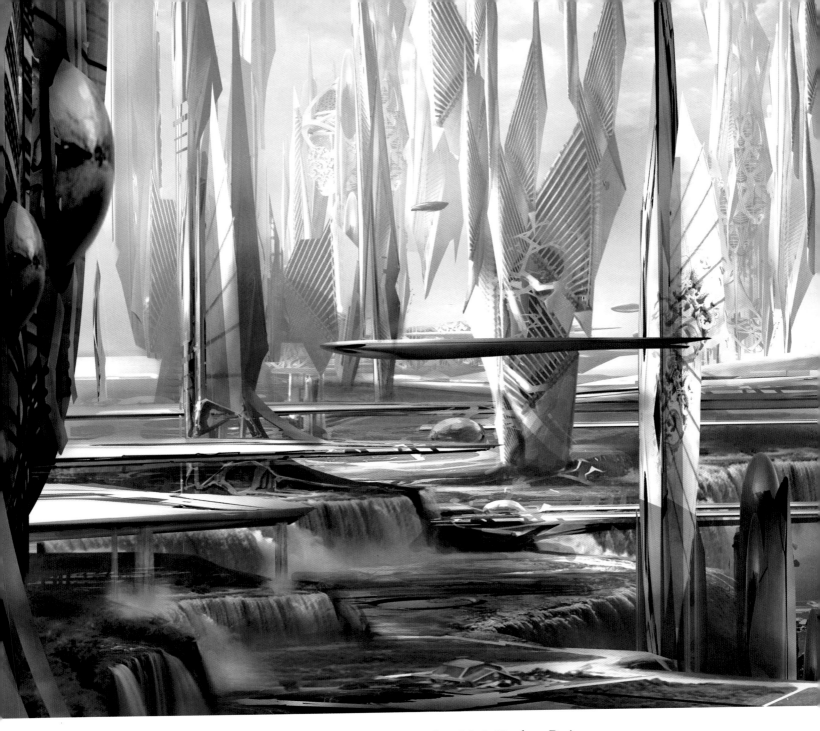

Above image: *Neo-Shanghai*. World Expo 2010 Shanghai, China. Copyright © Mario Kamberg Design.

Design and editing by Madelynn Martiniere
http://www.madelynnmartiniere.com

Printed in China
First edition, December 2011

Hardcover ISBN 13: 978-193349264-3

Library of Congress Control Number: 2011935925

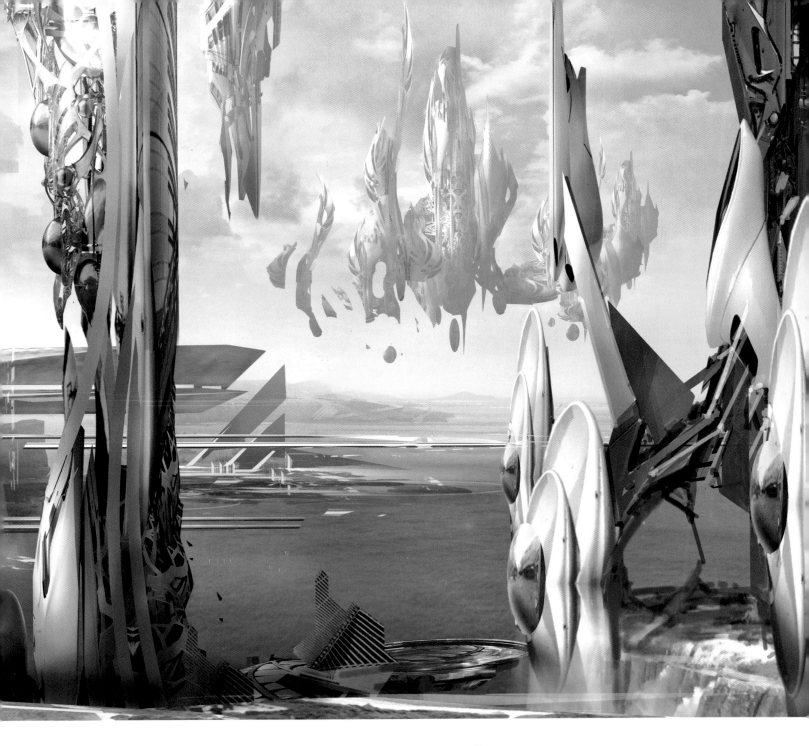

TABLE OF CONTENTS

FOREWORD

Some years ago now I began planning the writing of an epically scaled science fiction screenplay. I wanted to create something really unique and original which, I soon realized, was no easy task given the massive shadow cast visually by the 3 'star's of popular Sci-Fi; *Star Wars*, *Star Trek* and *Battlestar Galactica*. These iconic creations all feed off each other in various ways, as much as they each have their own specific influences from other movies, comics and artists. In seems all past Science-Fiction creations feed into creating the new and 'original' works. It's the ultimate liquid art form; blending, folding and merging ideas, styles and textures around new (or sometimes very old) stories again and again. So as a story creator, the quest to find a vision entirely different from what's come before is utterly crucial.

When I encountered Stephan's work for the first time I experienced what Joseph Campbell described as 'aesthetic arrest'. The experience is a simple beholding of the object, where one experiences a radiance and is held in a state of deepest enchantment. Campbell was describing Dante beholding the face of Beatrice, frozen in rapture by her otherworldly beauty. But it can just as easily be applied to the magical work of Mr. Martiniere.

His exquisite paintings literally drew me inside and, like all great fantasy or sci-fi artworks, I found myself not wanting to leave the worlds he had created. I wanted to stay and explore every detail, every side street, every rivet on each spacecraft, each star or swirling galaxy. So detailed, so committed to their wonderful imagined realities and with such an acute and unusual aesthetic – so far from anything I had ever seen before – I knew I'd stumbled upon an artist of pure, inspired genius. Here was someone with a vision (not to mention an extraordinary mastery of his craft) that was indeed, otherworldly. Painting after painting of mind-blowing, epic beauty unfolded. I made contact and graciously he accepted collaborating on the abovementioned project. We've spent some years creating work for it, building the imaginary world and universe of the story. We are still going and as much as I want to finalize the project, another part of me hopes that we can keep dipping into it for years to come. As when one receives that email heading, 'new sketch attached' from Stephan – it's nothing short of the best Christmas you've ever had as you scroll down and your jaw drops and you stare in amazement at his poetic and dazzling imagery. It's a creative imagination in full flight, and I feel truly privileged to have been able to collaborate with such a talent.

Now, if you're reading this you've more than likely seen Stephan's work before, so you know exactly how I feel, so I'm not telling you anything you don't already know. All I'm doing is reminding you – set aside a few hours because as you open this book and settle in to explore more of Stephan's amazing and unique imagination, you might find yourself leaving our world and not wanting to return for some time.

Greg Mclean June 2011
Writer/Director/Producer
(Wolf Creek, Rogue, Red Hill, Crawlspace)

INTRODUCTION

To my talented daughter, Madelynn, who has been incredible at helping me put this book together. From her sensibility as a writer to being my favorite model for many of my covers, she has supported my vision, contributed greatly to the creation of this book and made me the happiest dad in the world.

To my loving wife, Linda: I would not be the artist I am today without her constant support and help during all these years.

It is 2 o'clock in the afternoon on a Saturday, another blazingly hot summer day in Dallas. This has been my home now for several years and although Dallas doesn't have the architectural beauty or the cultural vibe of my previous hometown Chicago, this Texas town has grown on me. It is a convenient city, where everything I need is no more than 10 minutes away. Even more, I love my unique home with its organic shapes, handcrafted architectural elements, and just a hint of Japanese and Southwestern flair.

Coffee in hand, I walk to my office, sit down at my desk, fire up Adobe Photoshop and start my work. Whether I am finishing a project or starting a new one, I will likely work very late. Regardless of the many different places I have lived, this has been a consistent process and after all this time I still greatly enjoy it. I have been designing for the entertainment industry now for more than 25 years and there is still no greater satisfaction for me than to create and communicate interesting ideas, stories and emotions through concepts and illustrations.

As creative and enjoyable as it can be, it's not always an easy process. Finding the right ideas and properly executing them can be challenging. However that challenge often forces me to re-evaluate where I am artistically and pushes me to explore new things.

Velocity is my third art book. Following *Quantum Dreams* and *Quantumscapes*, this new book continues my artistic exploration as an illustrator and as a concept artist in various books films and game projects. As an illustrator, I continue to explore both painterly and graphic approaches. *Reading The Wind* and *An Autumn War* are great examples of these two different approaches and it is very likely that I will continue to push even further in both these directions in the future. As a concept artist in film and motion rides my interest and artistic drive is more about visualizing ideas and how to create compelling and original concepts. *The Looking Glass Wars* and *The Guardian* are good example of that process. I also wanted Velocity to showcase some different, much older projects like *Gulliver's Travels* and *Poseidon's Fury* to show the different styles and approaches that helped shape the many facets of the artist I am today.

From concept to painting, landscape to portrait, and creature to cartoon, I hope you enjoy Velocity as much as I enjoyed creating it.

Stephan Martiniere
Art Director and Concept Illustrator

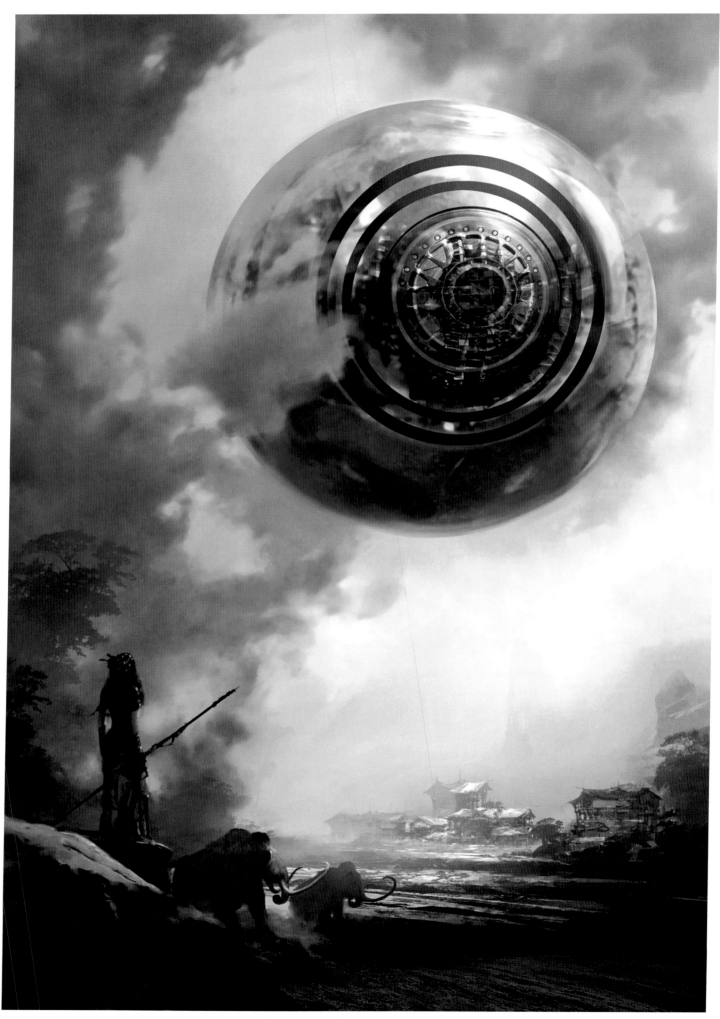

Elom, William H. Drinkard. Published by Tor Books

BOOKS

I always try to surprise myself when doing book covers. I look back on my first book covers like *Terraforming Earth* and *Cosmonaut Keep* and see how much my style has expanded. My first influence in book covers was Chris Foss because he broke out of the artistic conventions of space. Instead, he introduced radical new science fiction concepts both in palette and design. I always remind myself of his work and try to create something unexpected and iconic.

I love layering with light and color in a painting to create dynamic emotional pieces. *An Autumn War* was the first time I really broke away from the painterly style and tried to explore something much more graphic, and I was very pleased with the result. This was the first time I discovered a new style that resonated with me as much as the painterly technique. From that point forward, it gave me the opportunity to apply both styles depending on the subject of the painting.

Book covers completely rely on who you are as an artist. They give me a chance to be more adventurous than in any of the other entertainment fields. The images need to be powerful, detailed, and convey the mood of the narratives, while still speaking strongly of your style.

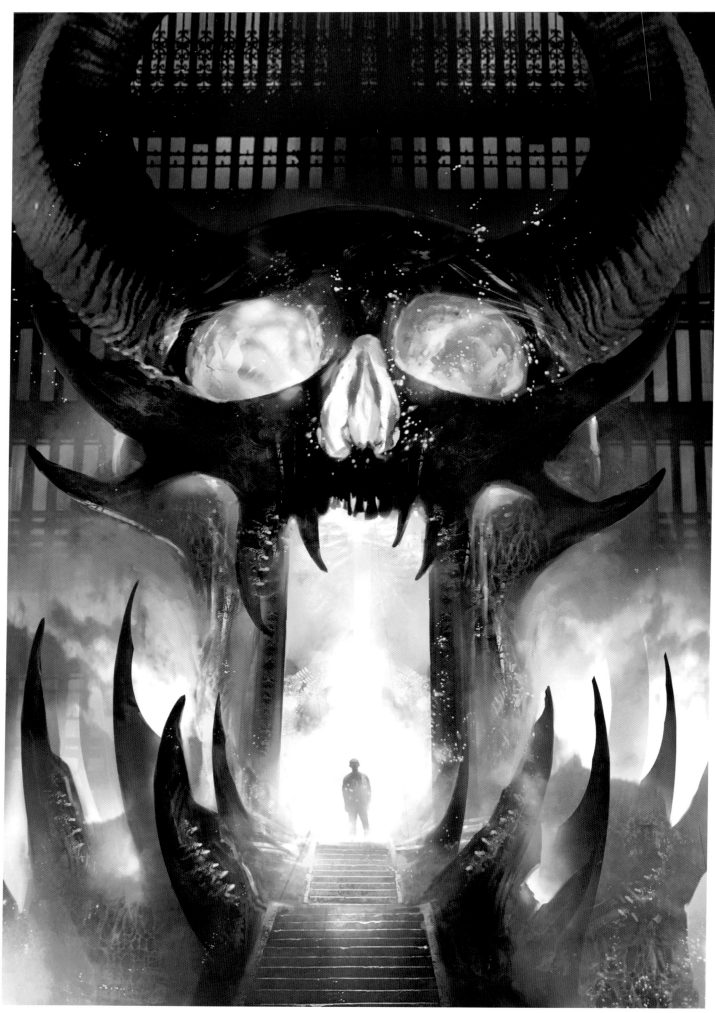

Inferno, Larry Niven and Jerry Pournelle. Published by Tor Books

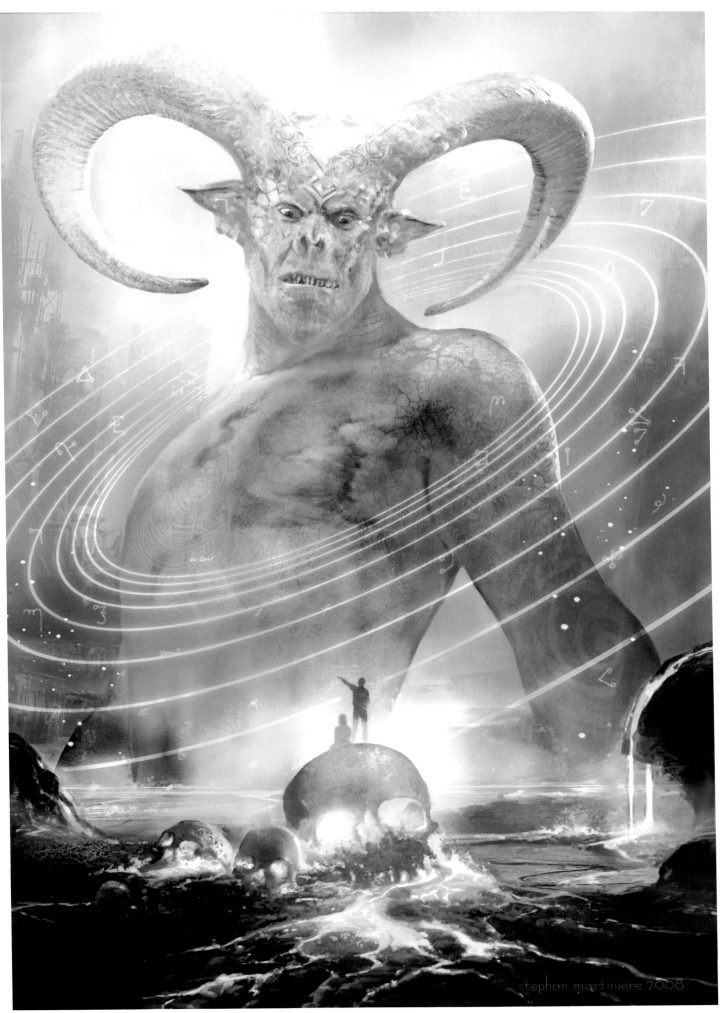

Escape from Hell, Larry Niven and Jerry Pournelle. Published by Tor Books

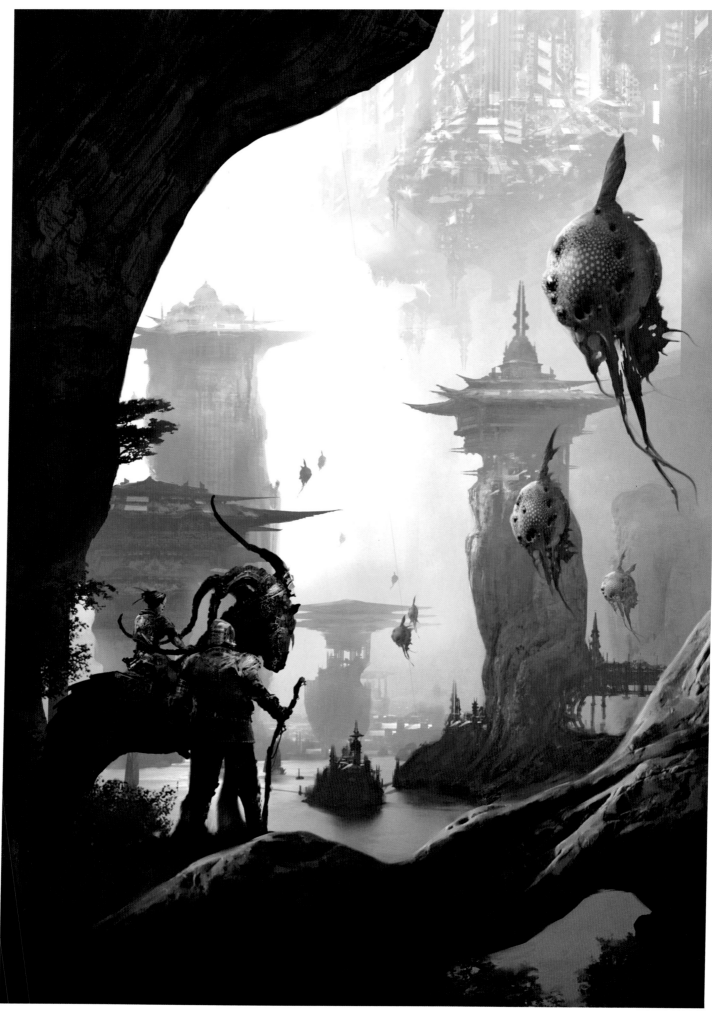

The Bright of the Sky, Kay Kenyon. Published by Pyr Books.

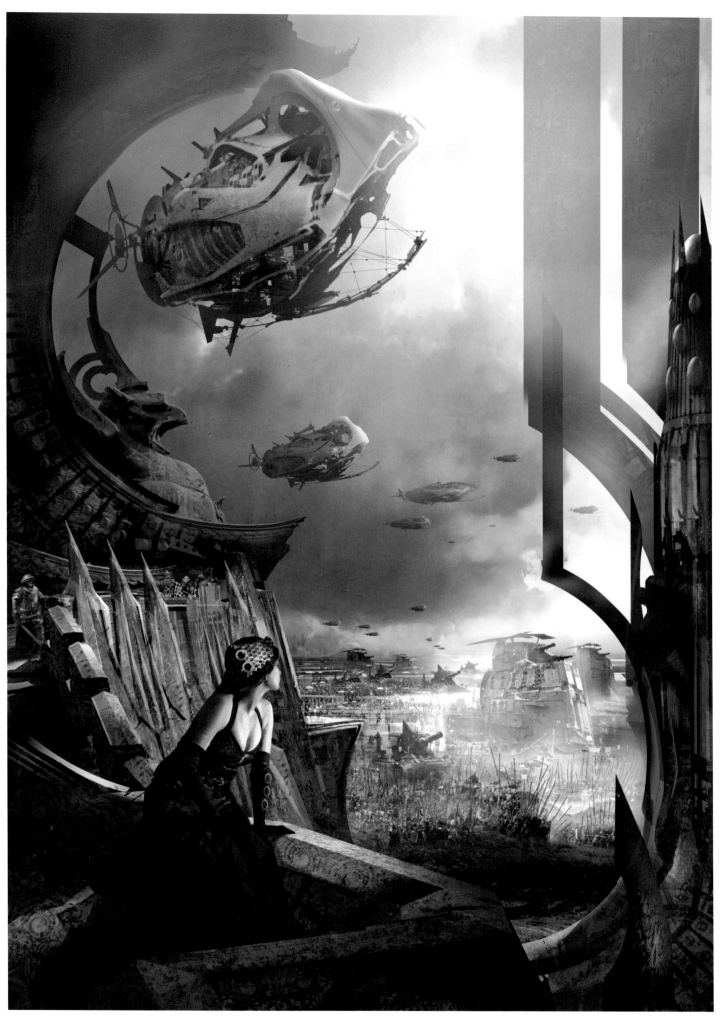

A World Too Near, Kay Kenyon. Published by Pyr Books.

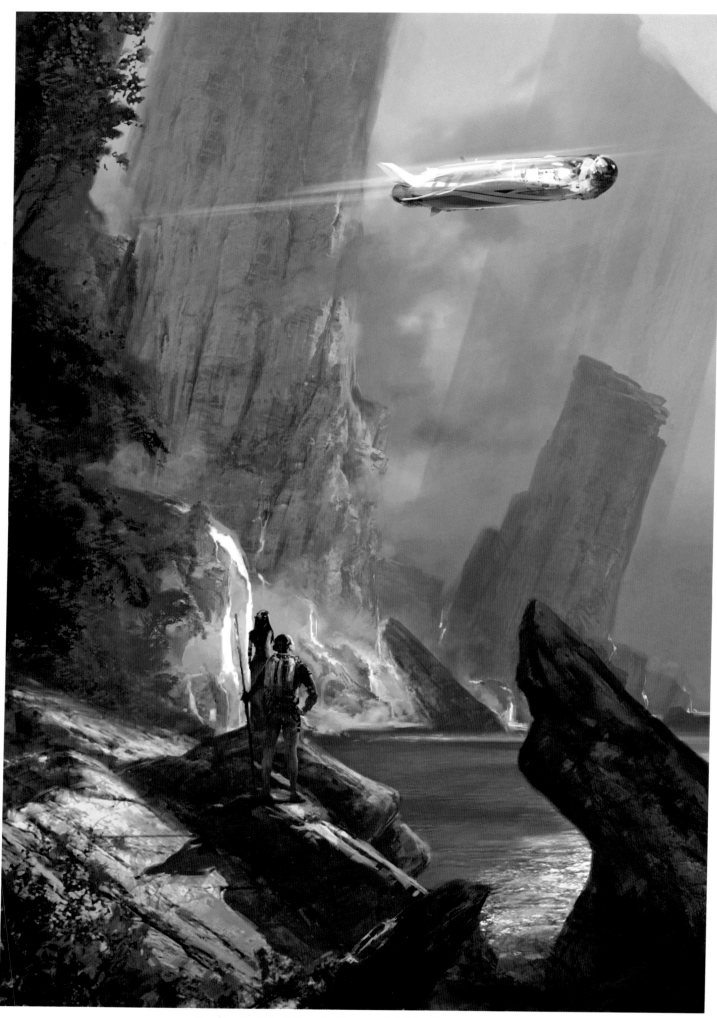

Reading the Wind, Brenda Cooper. Published by Tor Books

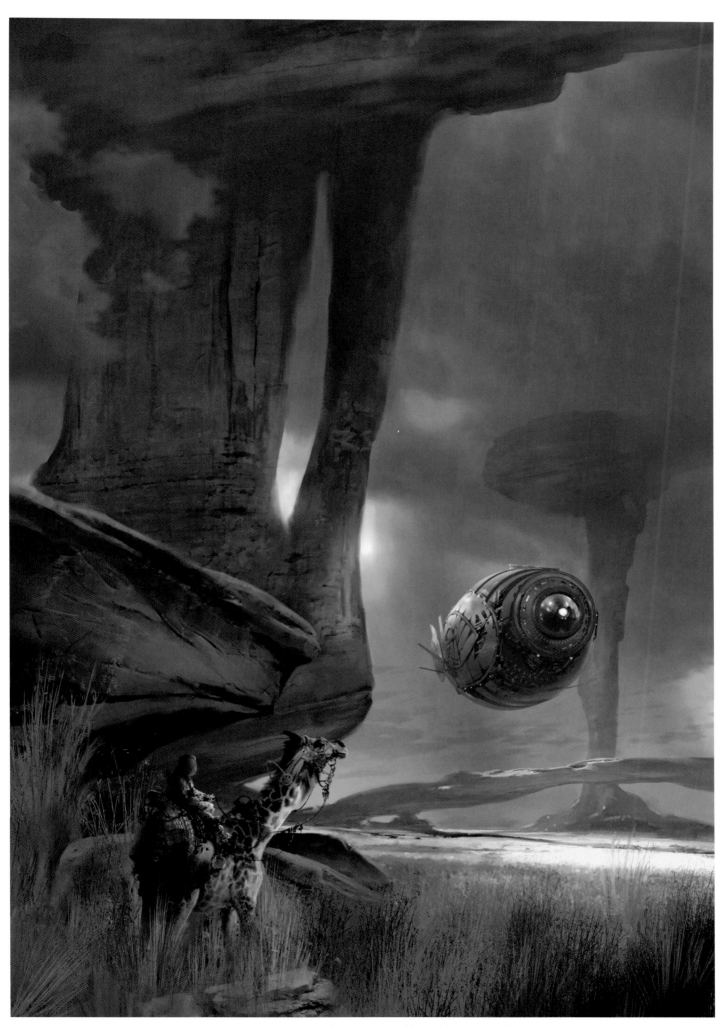

Ship and the Sea, Brenda Cooper. Published by Tor Books

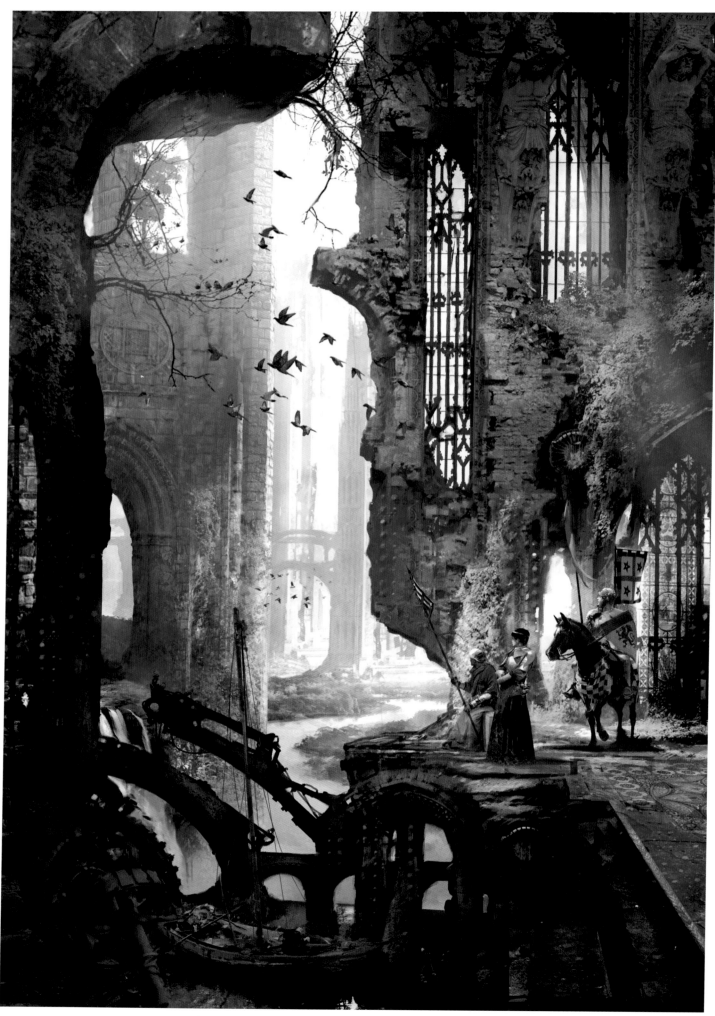

The Price of Spring, Daniel Abraham. Published by Tor Books

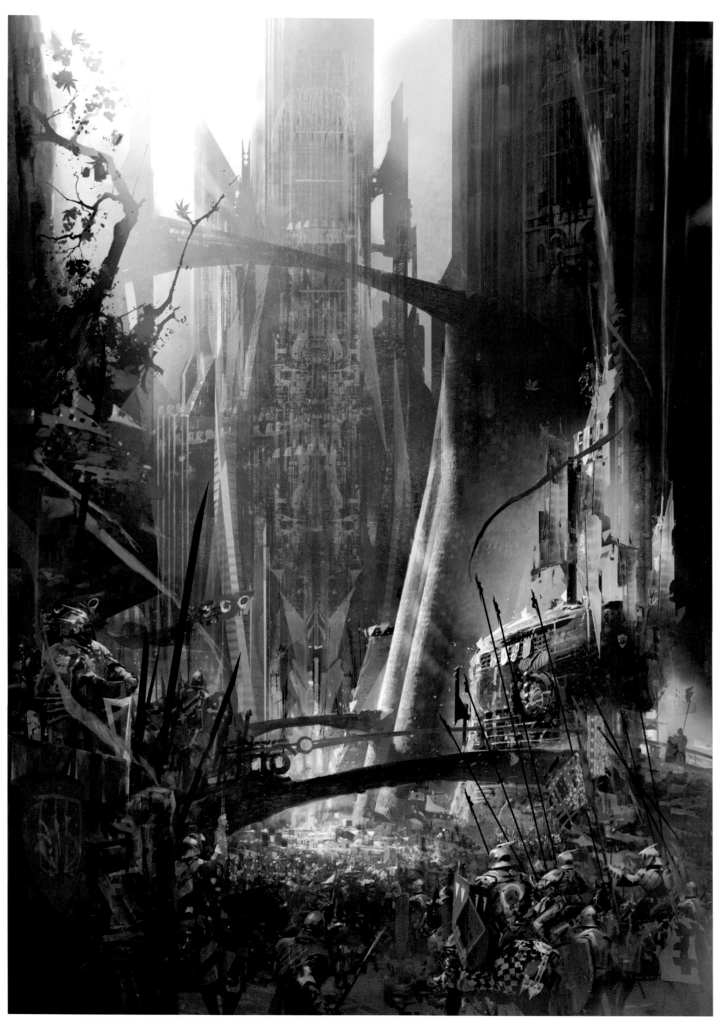

An Autumn War, Daniel Abraham. Published by Tor Books

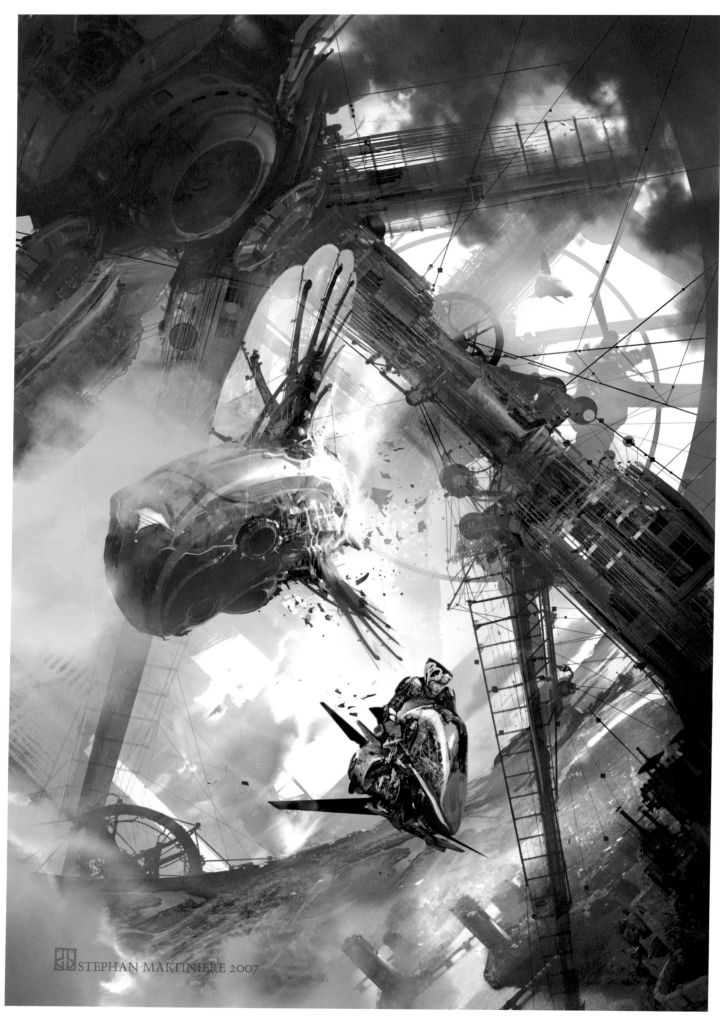

Pirate Sun, Karl Schroeder. Published by Tor Books

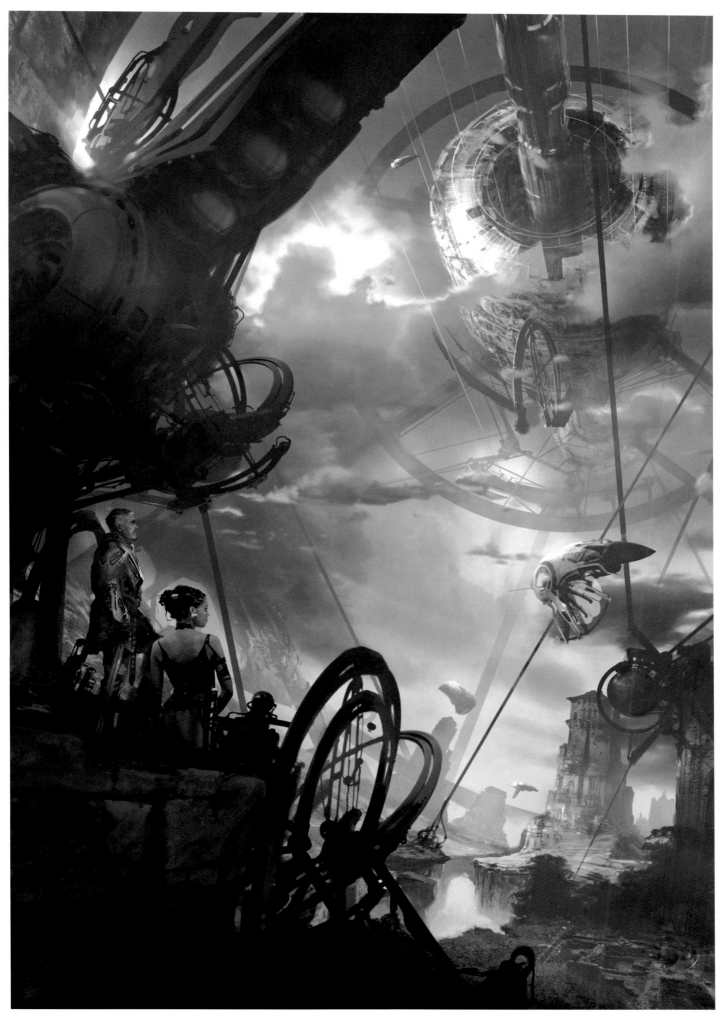

Queen of Candesce, Karl Schroeder. Published by Tor Books

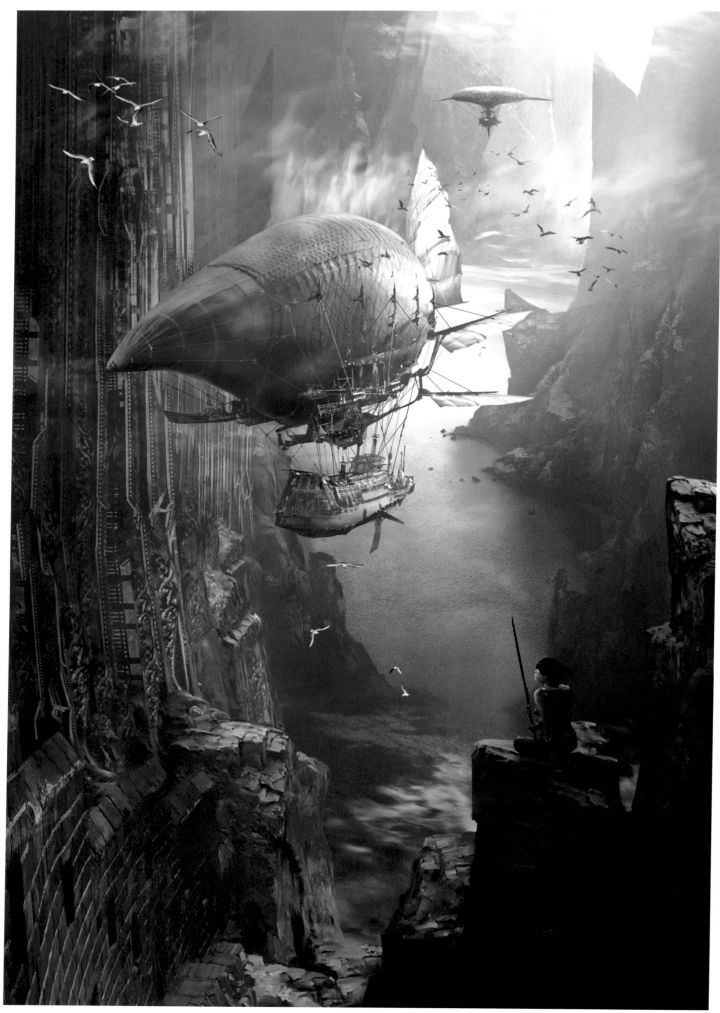

Escapement, Jay Lake. Published by Tor Books

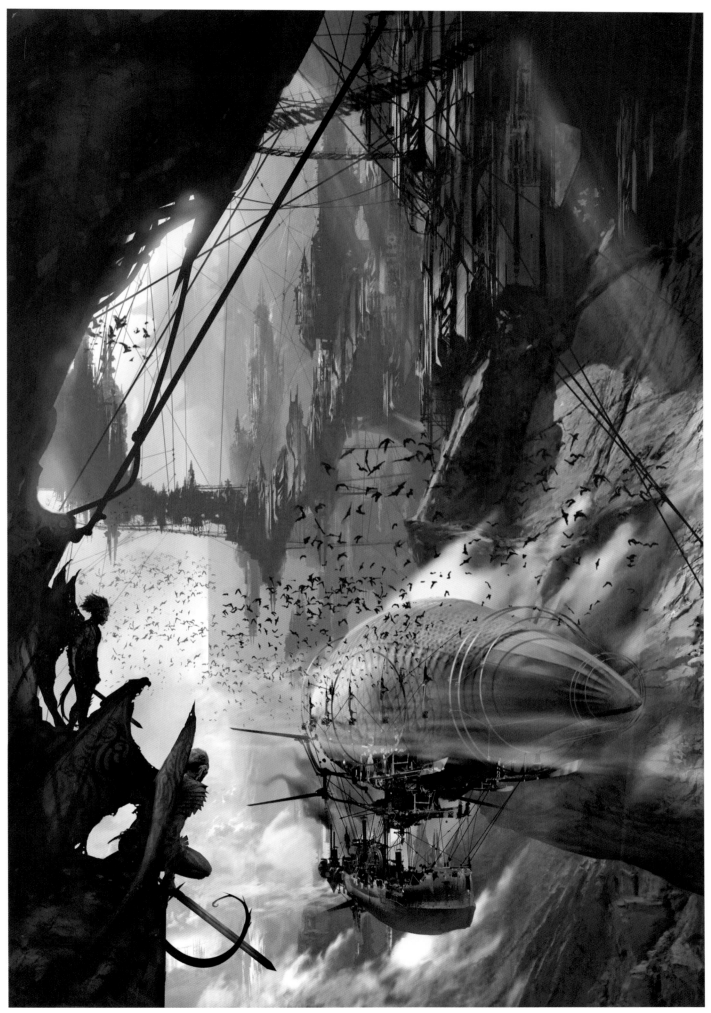

Mainspring, Jay Lake. Published by Tor Books

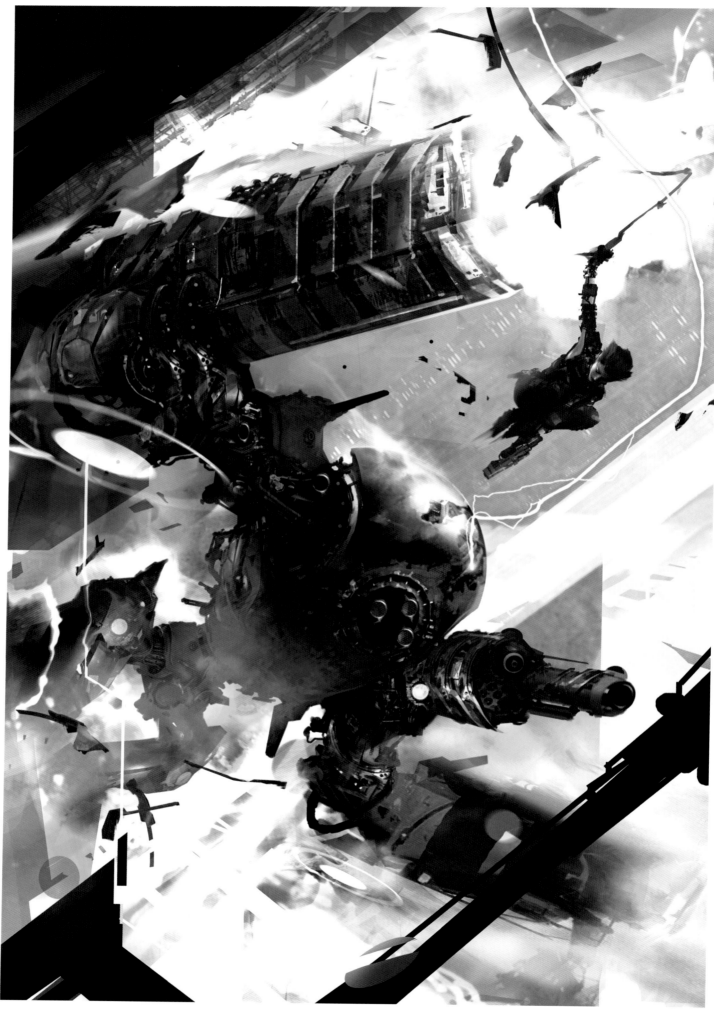

Killswitch, Joel Shepherd. Published by Pyr Books

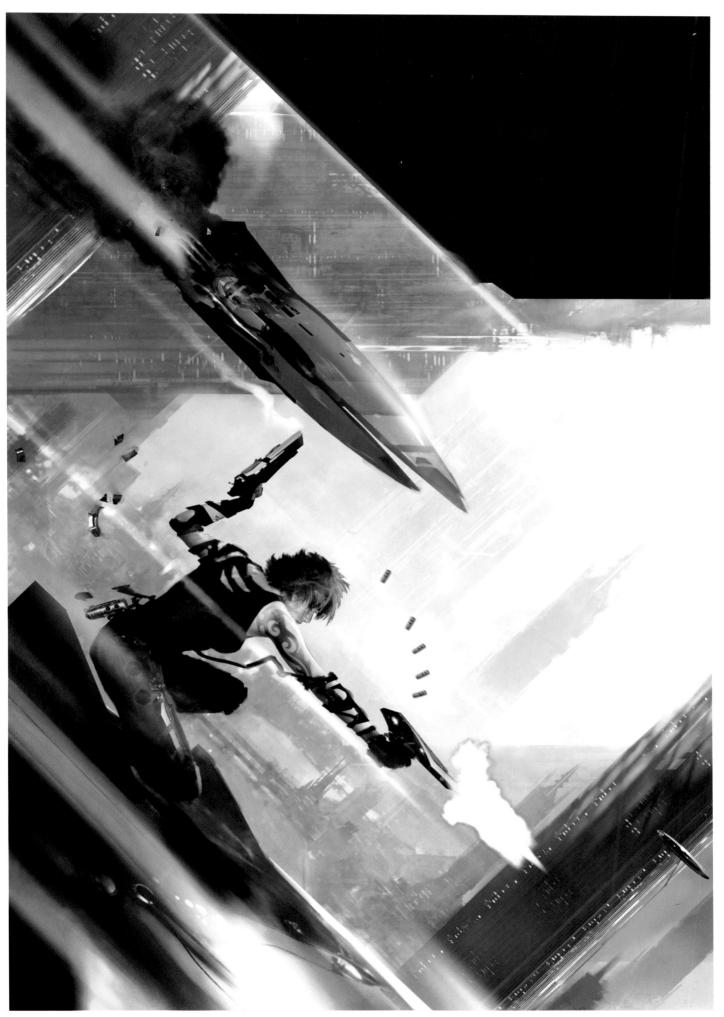

Breakaway, Joel Shepherd. Published by Pyr Books

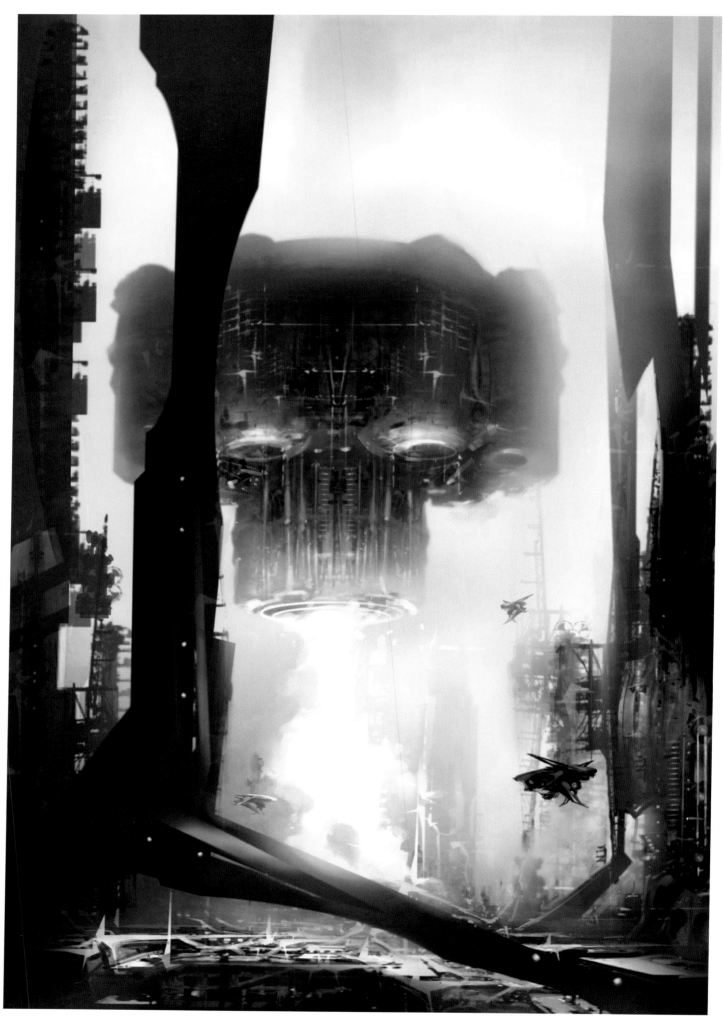

Outbound, Jack McDevitt. Published by ISFIC

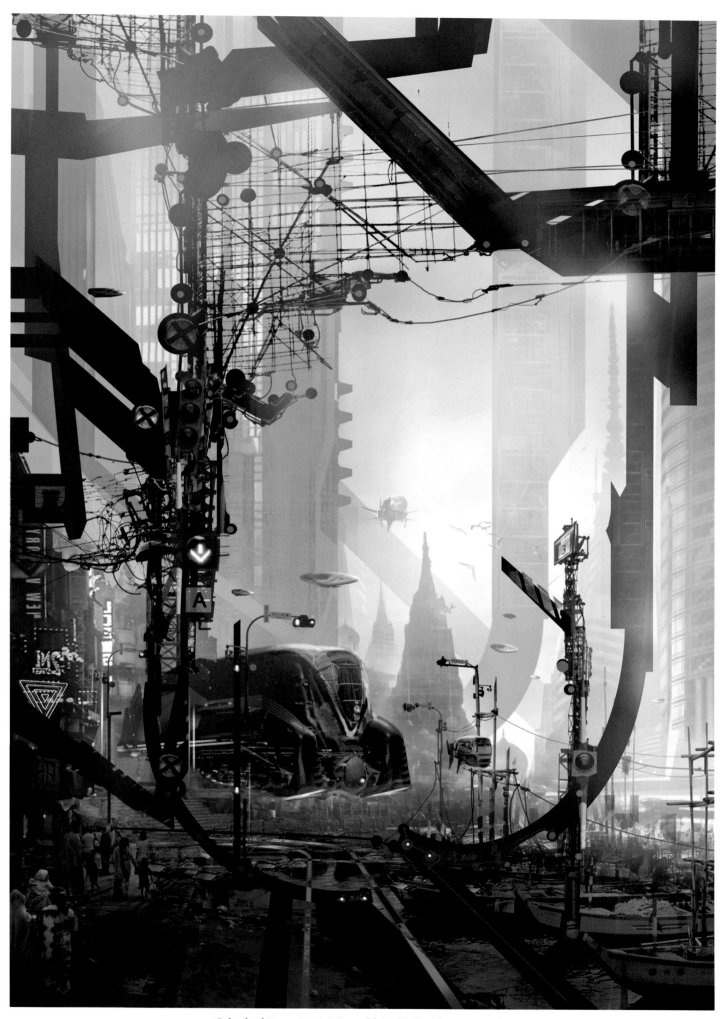

Cyberbad Days, Ian McDonald. Published by Pyr Books

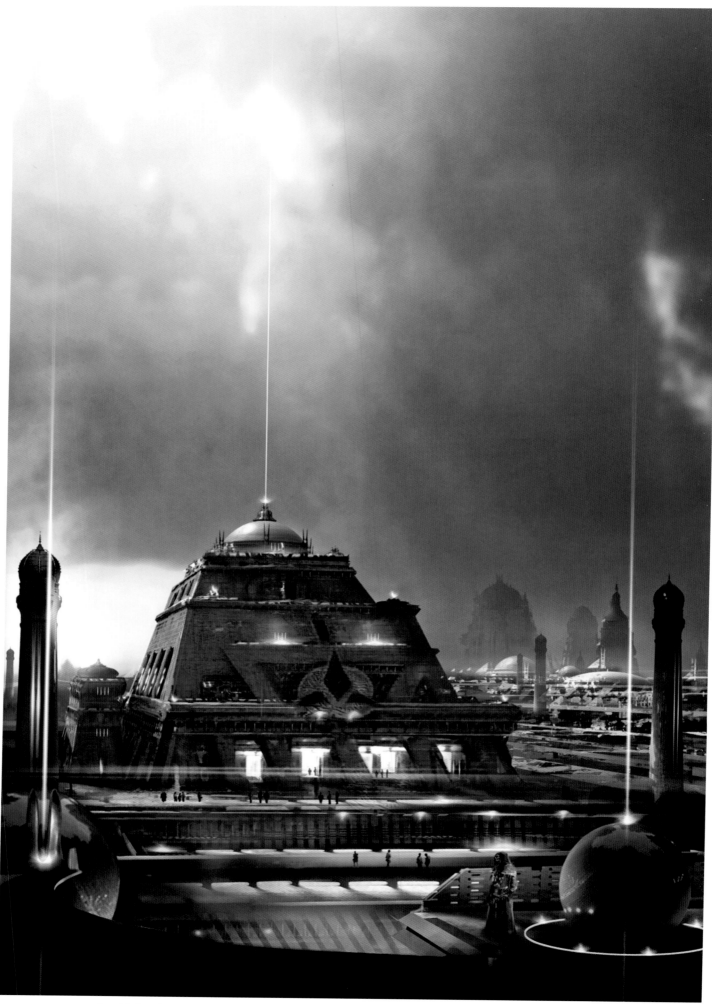

Star Trek: Klingon Empire, A Burning House, Keith R. A. Decandido. Published by Pocket Books

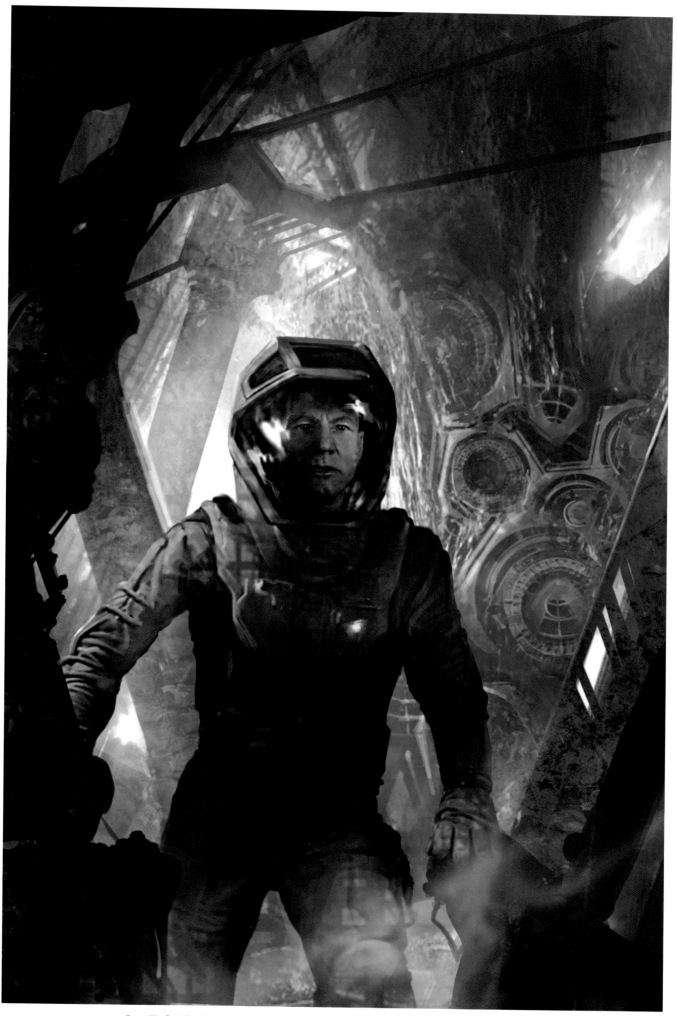

Star Trek: The Buried Age, Christopher L. Bennett. Published by Simon & Schuster

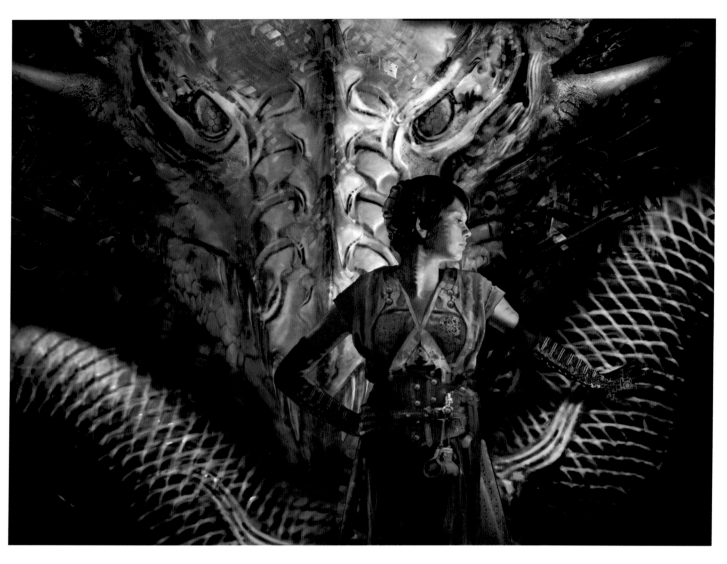

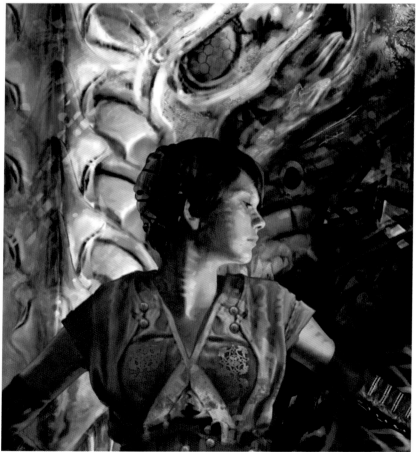

The Iron Dragon's Daughter, Michael Swanwick. Published by SFBC

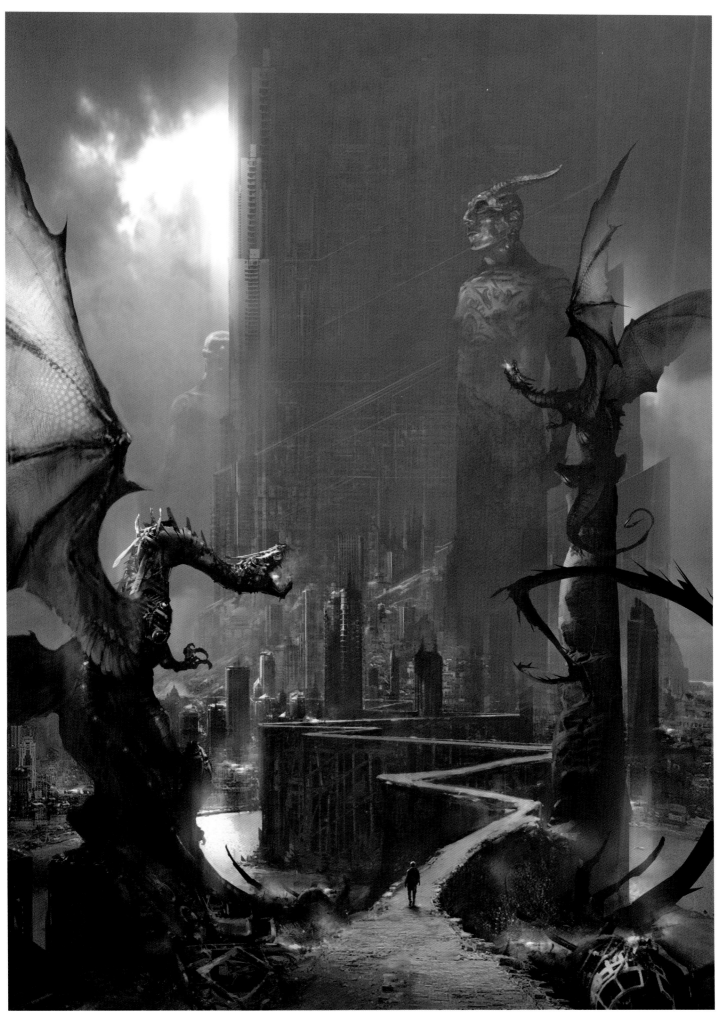

The Dragons of Babel, Michael Swanwick. Published by Tor Books

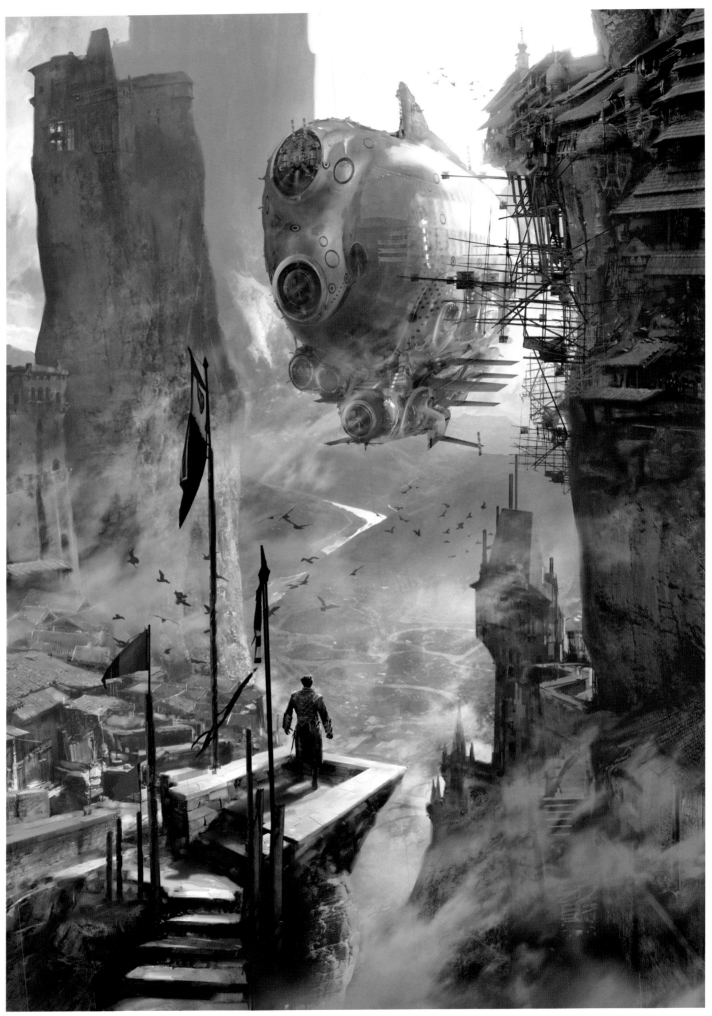

Retribution Falls, Chris Wooding. Published by Orion Press

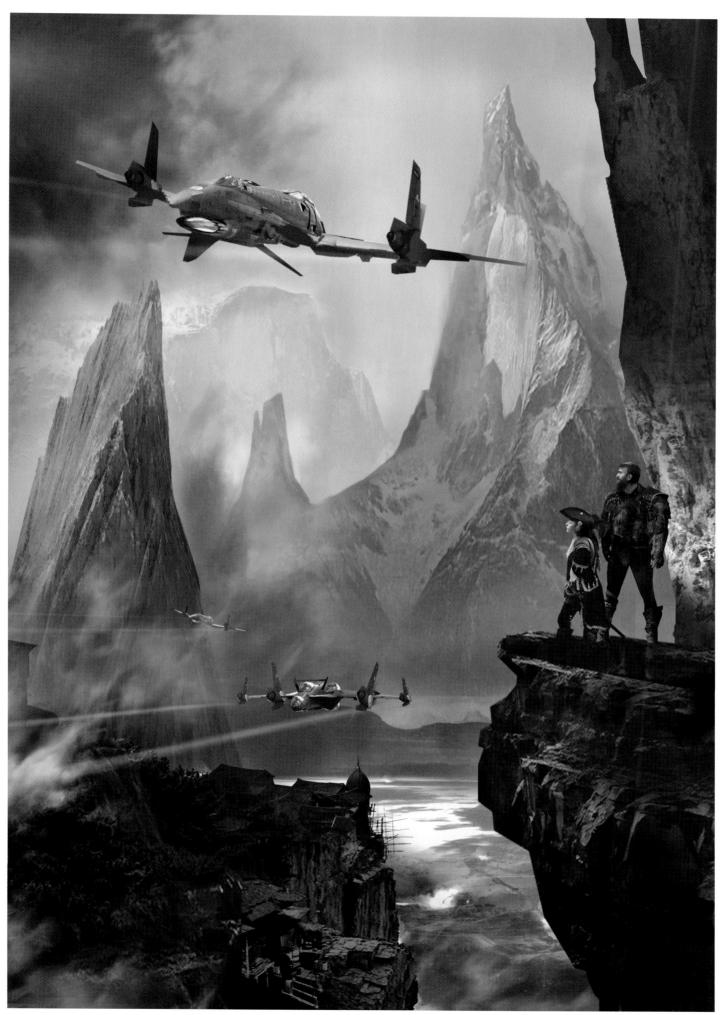

The Black Lung Captain, Chris Wooding. Published by Orion Press

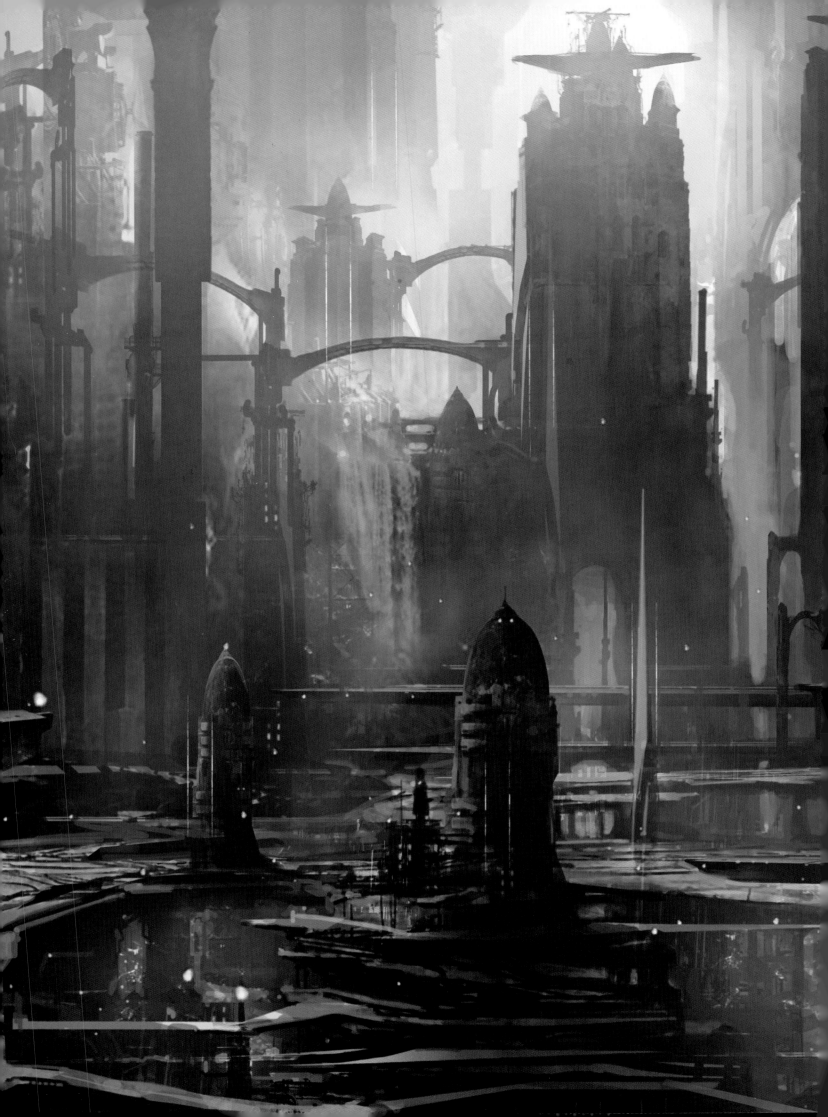

GAMES
FILMS
RIDES

Films, games, and theme park rides offer many more levels of interaction than book covers. Each project comes with its own degree of technical challenges, but they are an exciting adventure each time, so it's difficult to ever get bored.

Creating concept for film and theme parks to me is about the production process. It is about taking a creative idea and understanding what it means to turn that idea into a compelling and workable vision. With movies, you can sit back and enjoy the result, but you can't interact with it. On the other hand, with theme parks you are completely immersed in the final result. Everything you create is tangible; whether it is built as an animatronic or elaborate sets. Games come with their own set of technical limitations. In the instance of *Magic: The Gathering*, the small size requires something quick and artistic rather than producing something bold and complex.

Regardless of their differences, each offers a unique level of creativity and experimentation that I have continued to enjoy for many years.

(opposite) Ravnica, Magic: The Gathering

MAGIC: THE GATHERING

Though I love doing both environments and creatures, in this collection I wanted to concentrate exclusively on creatures. This series of illustrations was done for the new Phyrexia pack for the card game Magic: The Gathering. I love the richness and complexity of the Magic world. My work for Magic is always an interesting challenge because it forces me to think efficiently due to the card size limitations, Ultimately, what the players will look at is a very small size hence the illustrations need to read well quickly. I enjoy that the Magic cards need to have a very painterly style, as it gives me an opportunity to explore different brushes and styles while working increasingly with Painter.

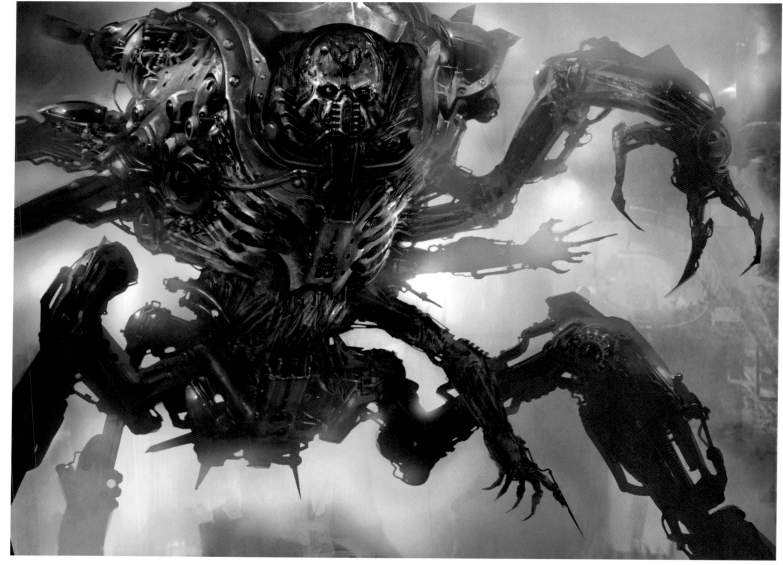

New Phyrexia "Rager"

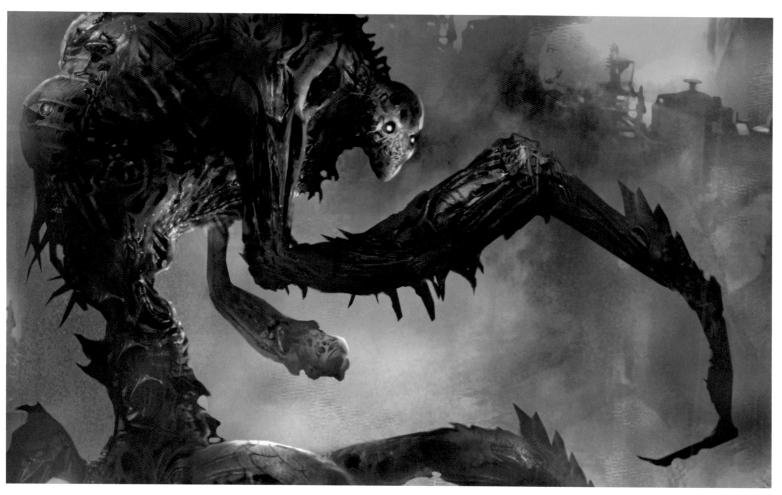

New Phyrexia "Reaper of the Sheoldred"

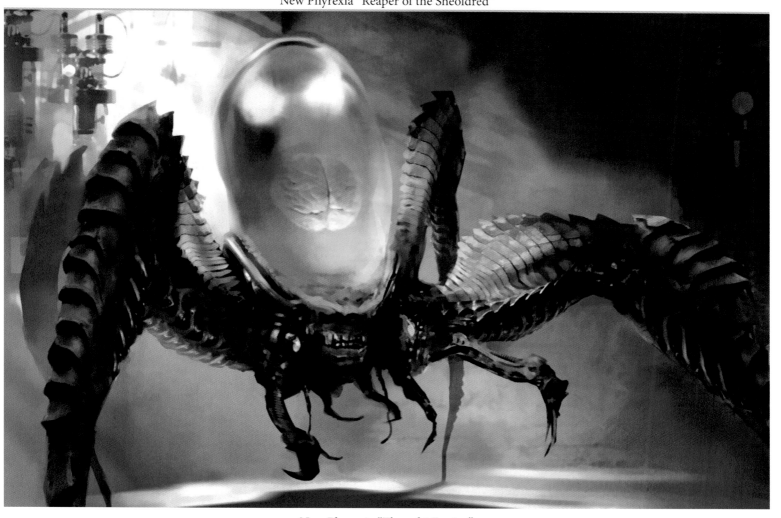

New Phyrexia "Thought Engine"

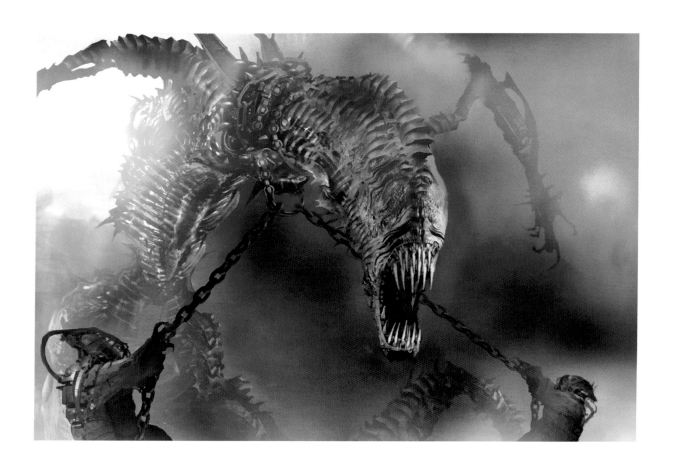

(above)New Phyrexia "Chained Throatseeker"

(opposite)New Phyrexia "Chancellor of the Dross"

(below)New Phyrexia "Blood Crawler"

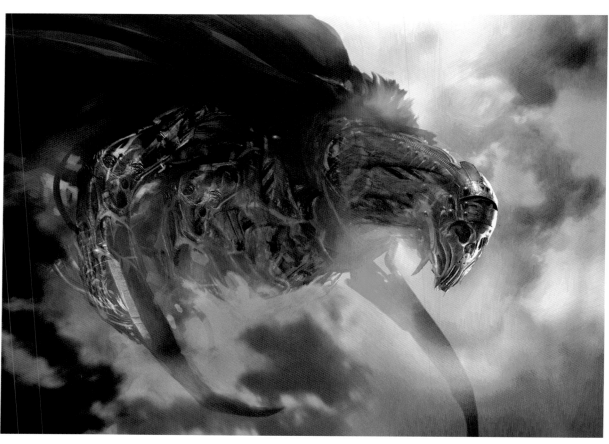

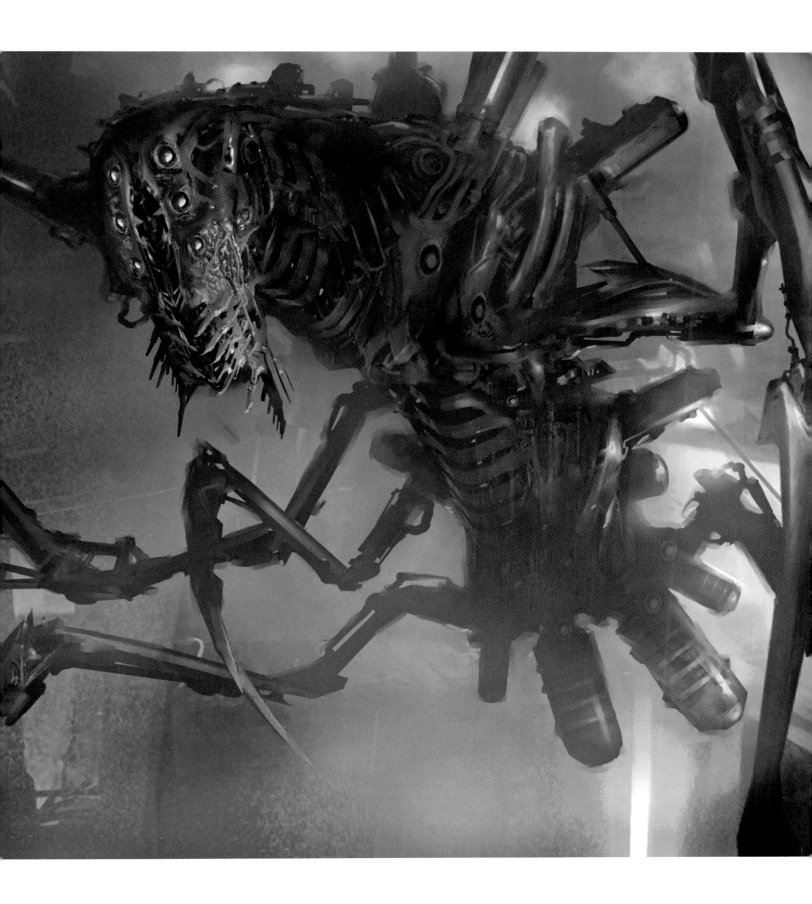

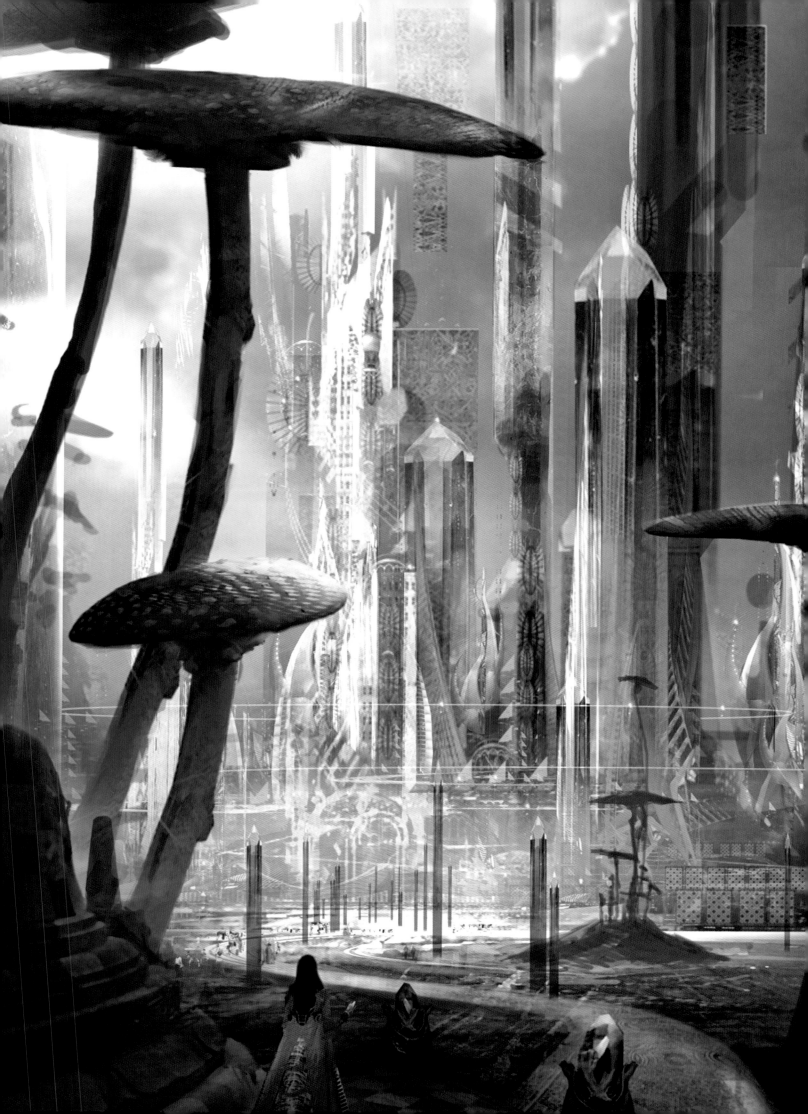

THE LOOKING GLASS WARS

This project is an interesting reimagining of the Alice in Wonderland story. Author Frank Beddor was interested in stepping away from the previous whimsical imaginings from Disney and others, and instead created something serious and dark. I had great fun creating Alyss and some of the soldiers. These concepts were done very quickly without any sketches, as I often do. I wanted to start with an idea in my head and let the process of layering different color washes and images dictate the outcome. As I was creating one hostile soldier after the other I found myself a bit caught up in this dark take on the Lewis Carroll story, and found the project ultimately both weird and fun.

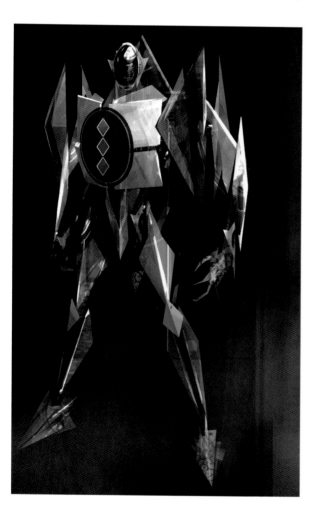

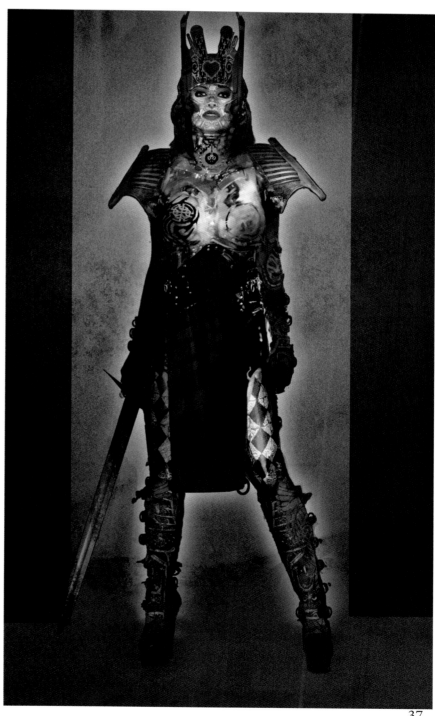

(above) Generic Card Soldier

(opposite) Wondertropolis

(right) Alyss

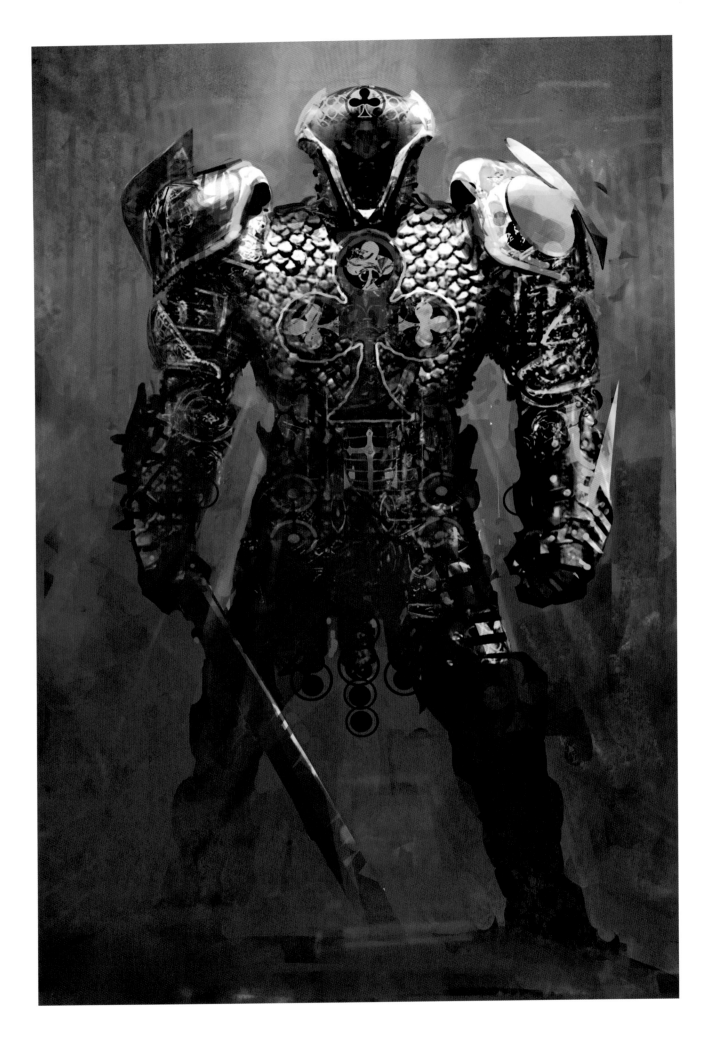

(from left to right) Various Heavy Card Soldiers

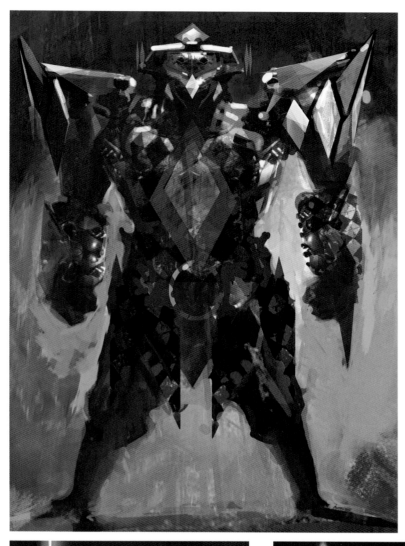
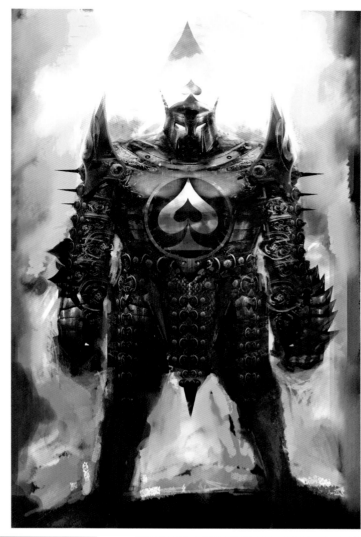
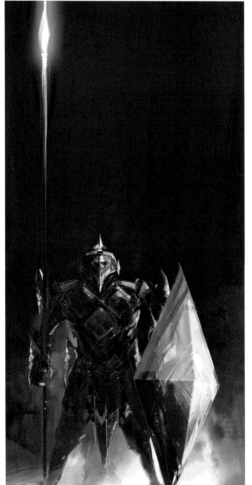
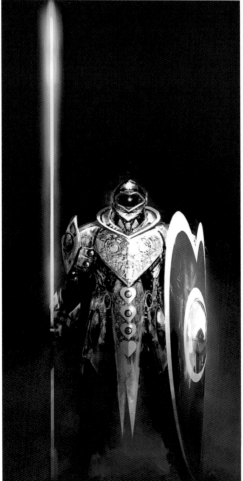
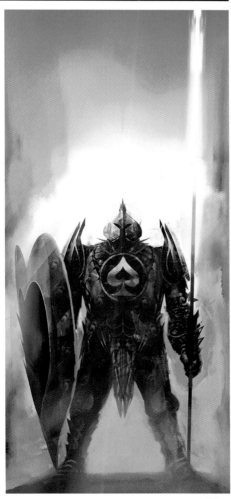

POSEIDON'S FURY

These concepts were done for a Universal in teractive and special FX show in Orlando, FL. As a water screen poured down around the audience, a CG film was projected on the sur face giving the audience the feeling of looking at an underwater city. Everything was care fully scripted: from graceful whales and play ful mermaids swimming between the arches, to the battle between the ancient titans Posei don and the evil Darkenon. There were a lot of both classic and stylized explorations for both titans as they were the main focus of the show. I was able to explore a mix of both classic Greco-Roman architecture along with some organic underwater shapes reminiscent of seashells and jellyfish.

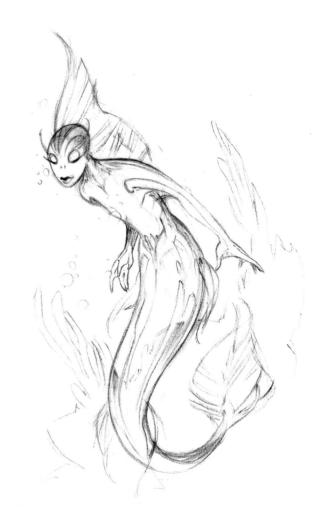

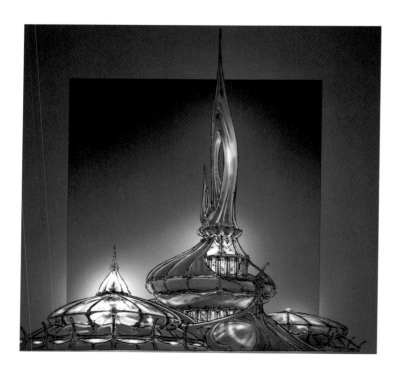

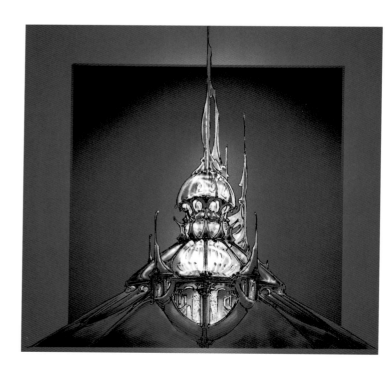

(above and opposite) Various Structure and Building Ideas for Atlantis

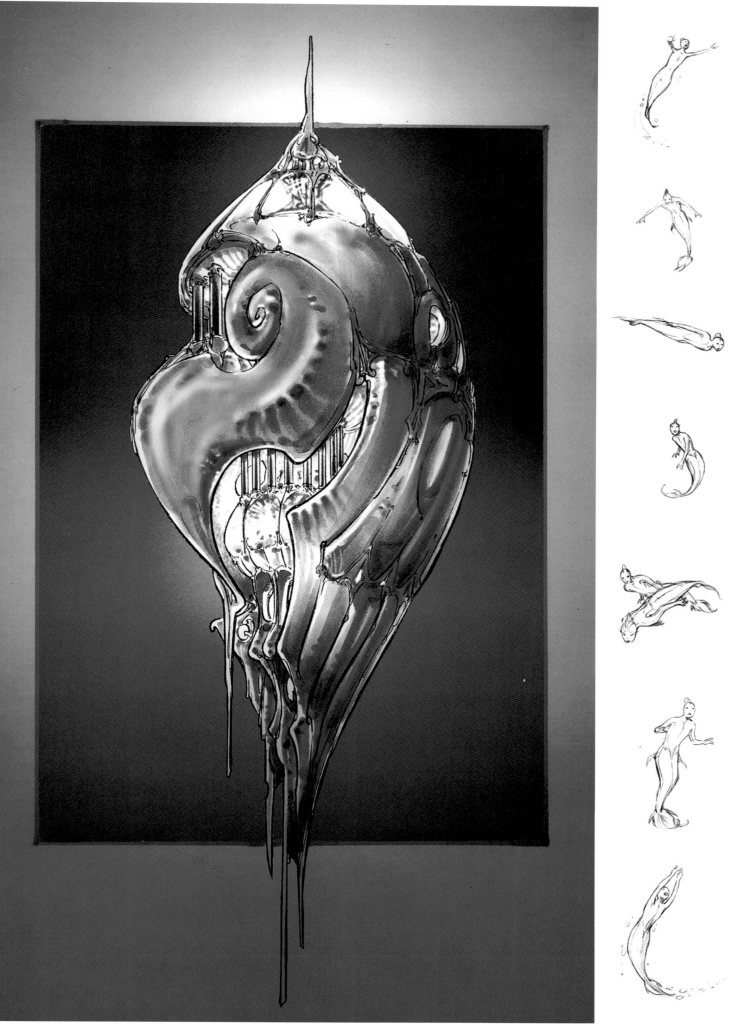

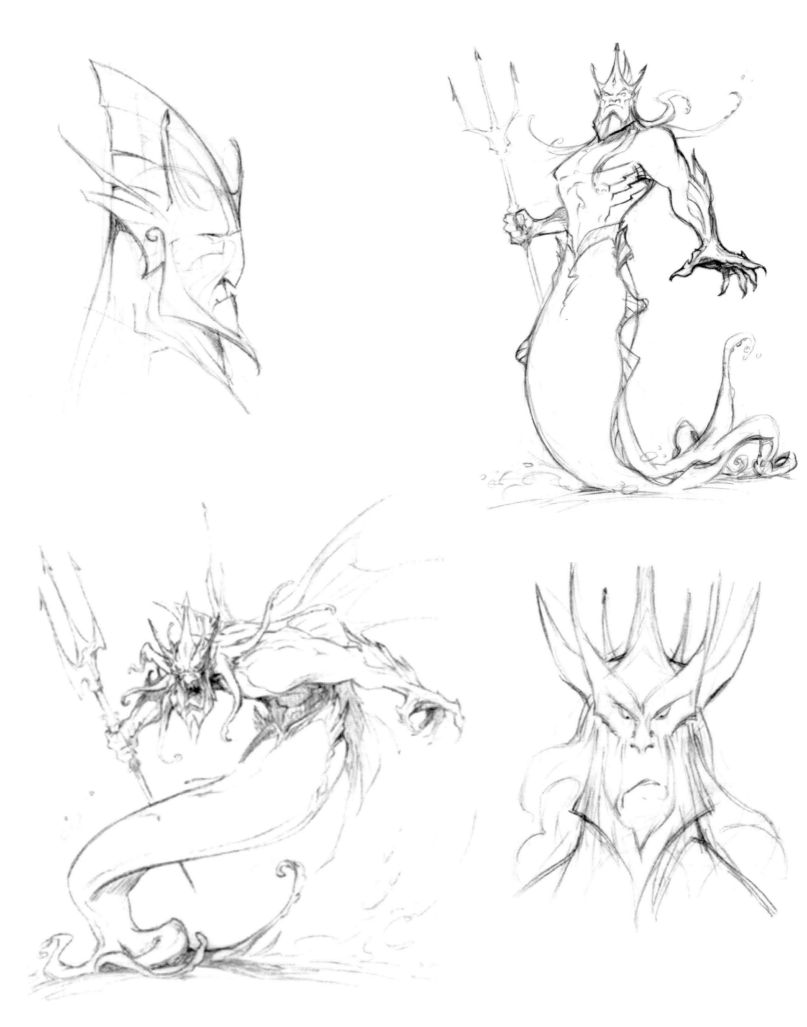

Various Concepts for Darkenon

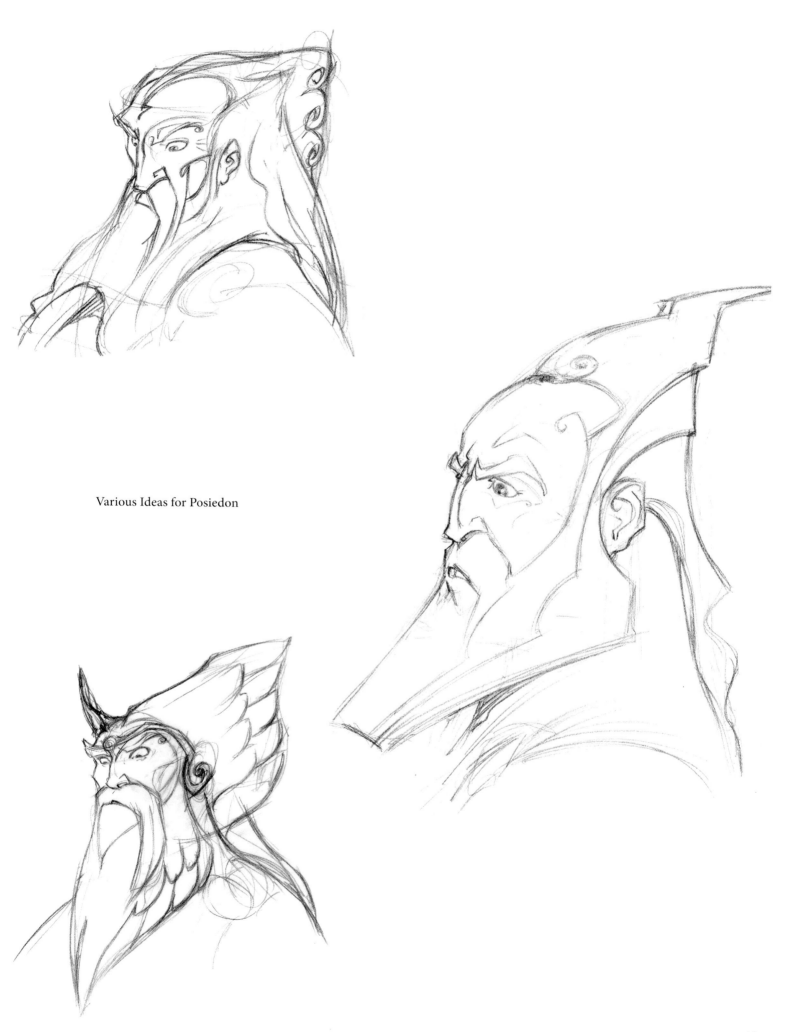

Various Ideas for Posiedon

THE GUARDIAN

The Guardian is a science fiction film project for the film director Greg McLean. It's a great premise and artistically this was certainly the most exciting film project I have worked on in the last few years. It has a vast and extremely diverse universe with thousands of strange and frightening worlds inhabited by weird and exotic alien races. McLean was very interested in letting me explore different ideas and see what my take would be regarding the look of the different alien races. I thought this was a great opportunity to explore some unusual concepts and new ideas. Along with the traditional humanoid shapes, I also wanted to explore some alien life forms that would be more unusual and organic, made of translucent matter or complex energy. I worked on the project for several months and really only scratched the surface of the possibilities.

(bottom) The Kreener Fleet Taking Off

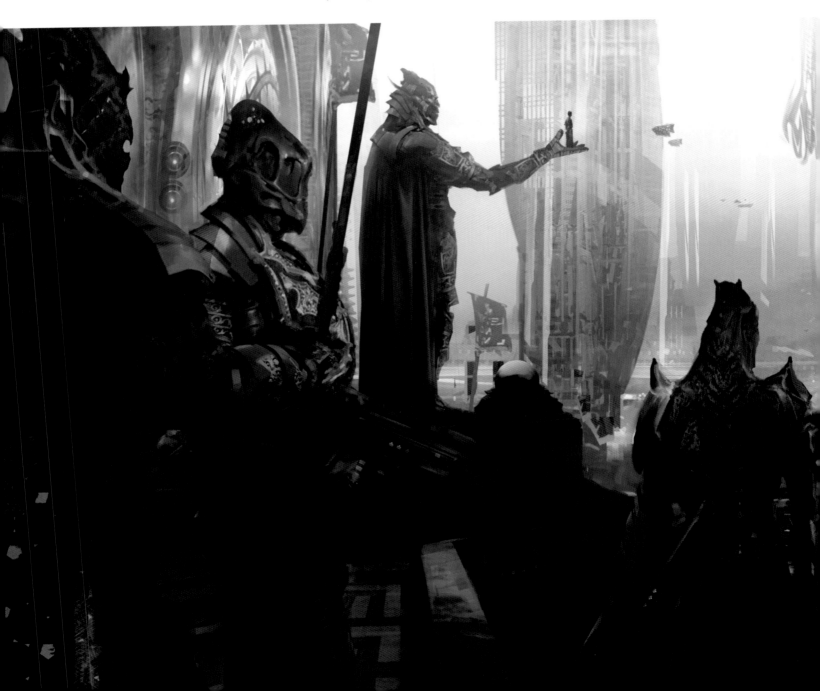

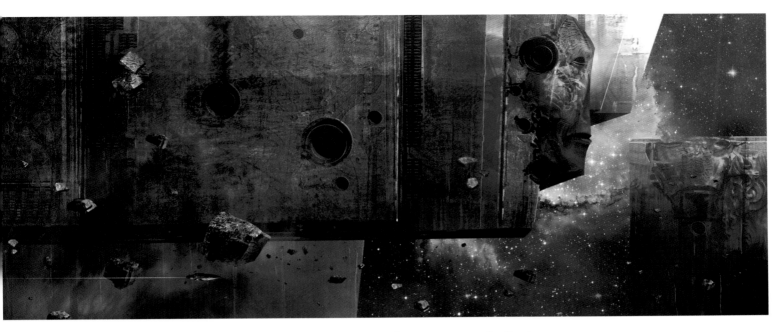

(top) Derelict Space Structures from an Ancient Civilization

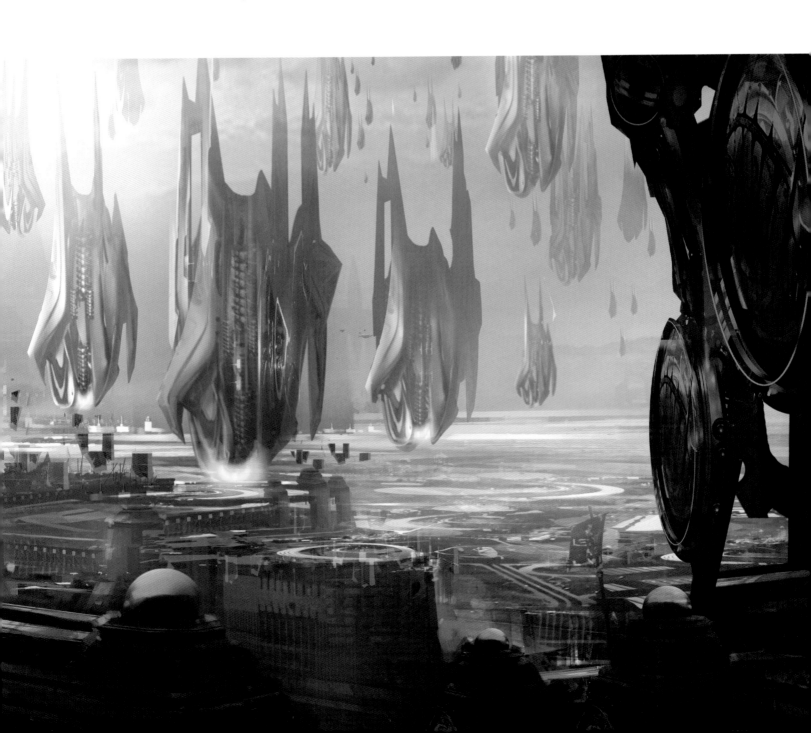

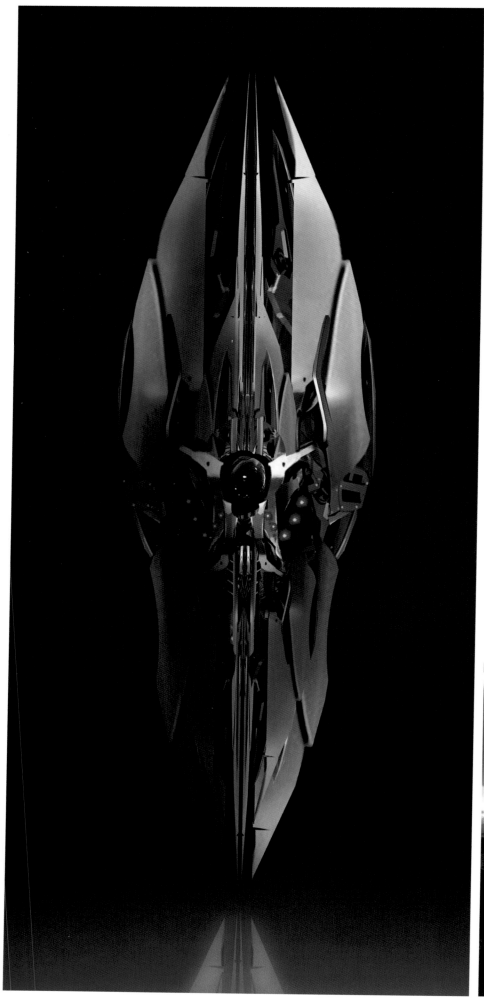

(left) The Narcolion Folded

(opposite) The Narcolion Unfolded

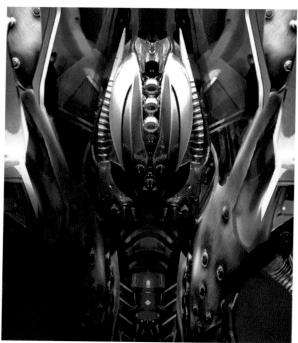

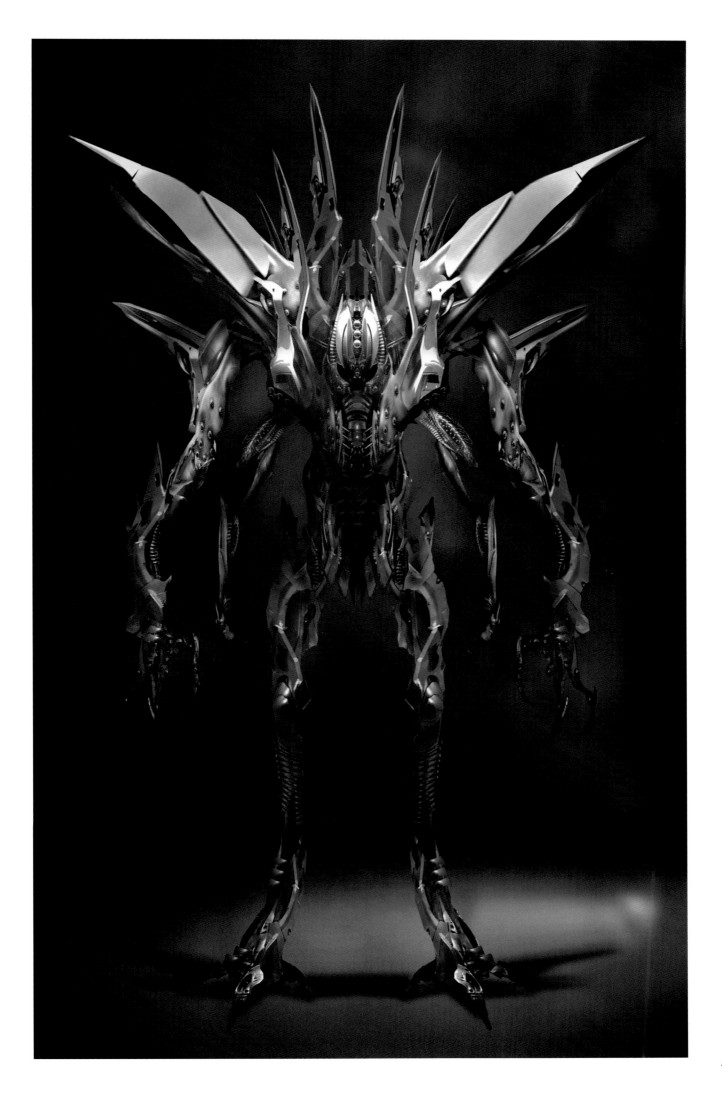

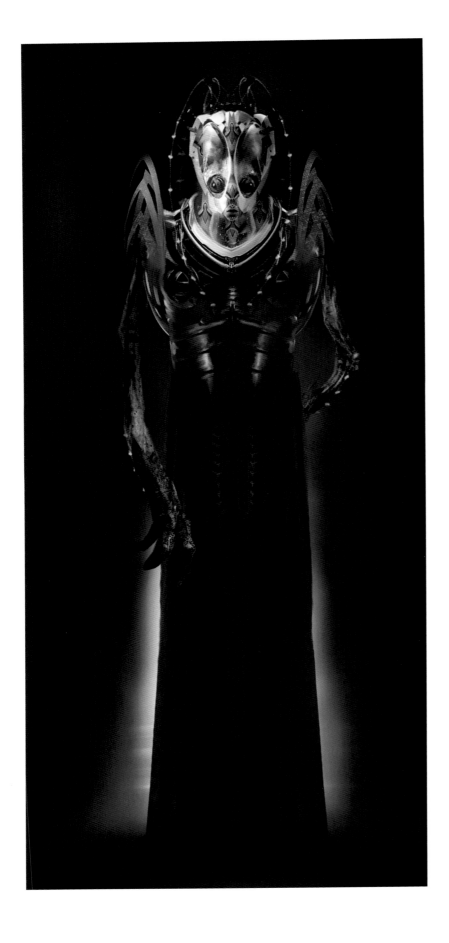

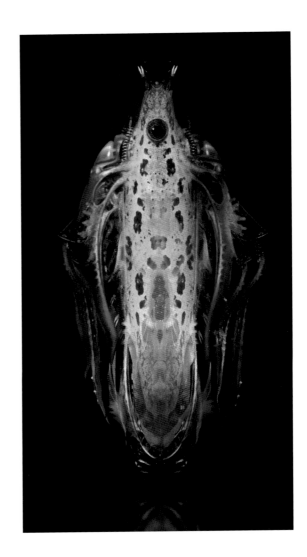

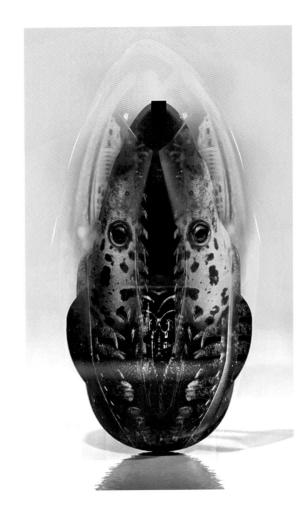

Various Greturion City Alien Concepts

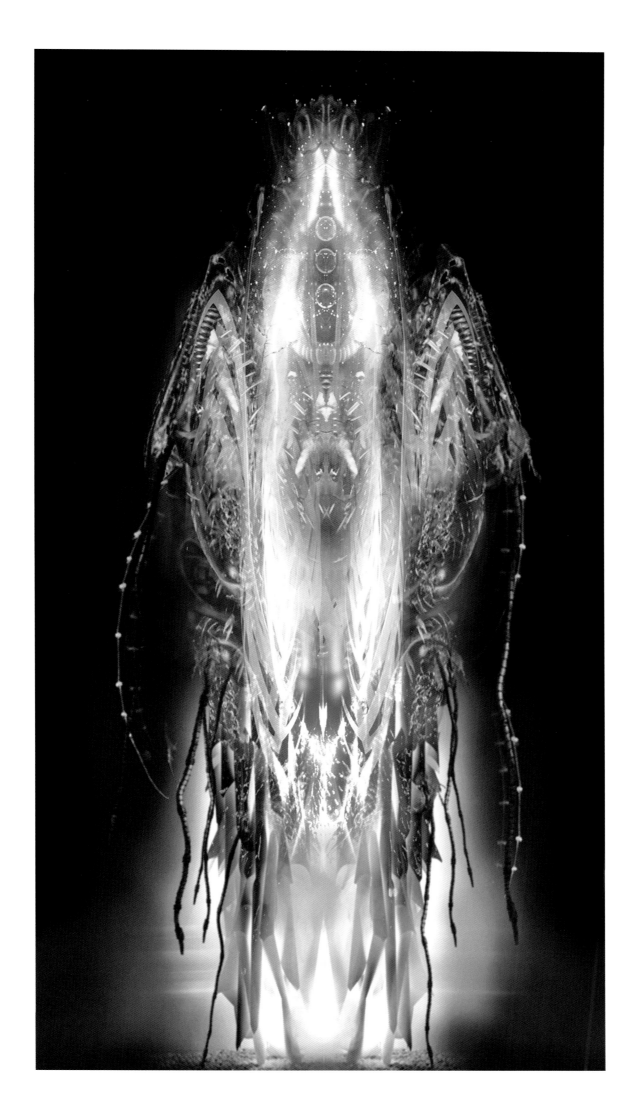

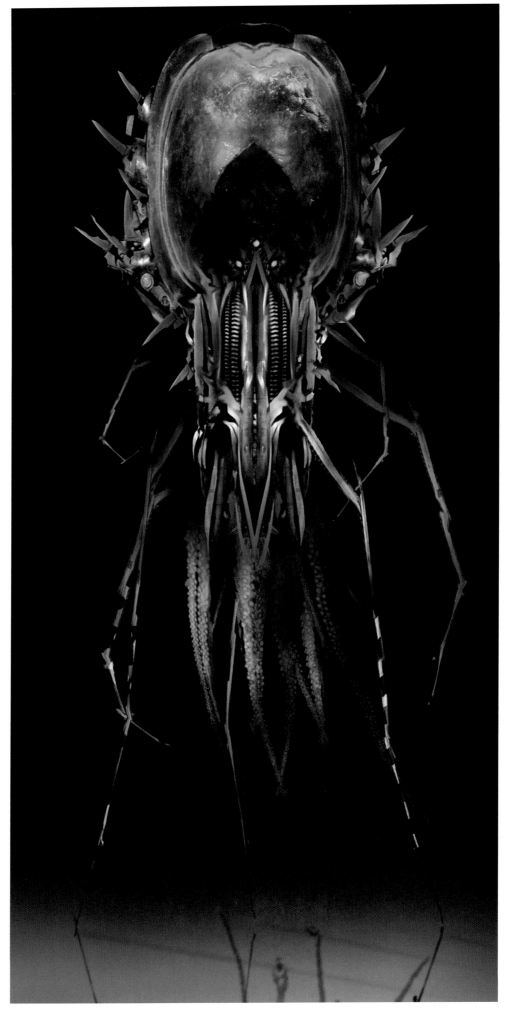

Gannon Vee

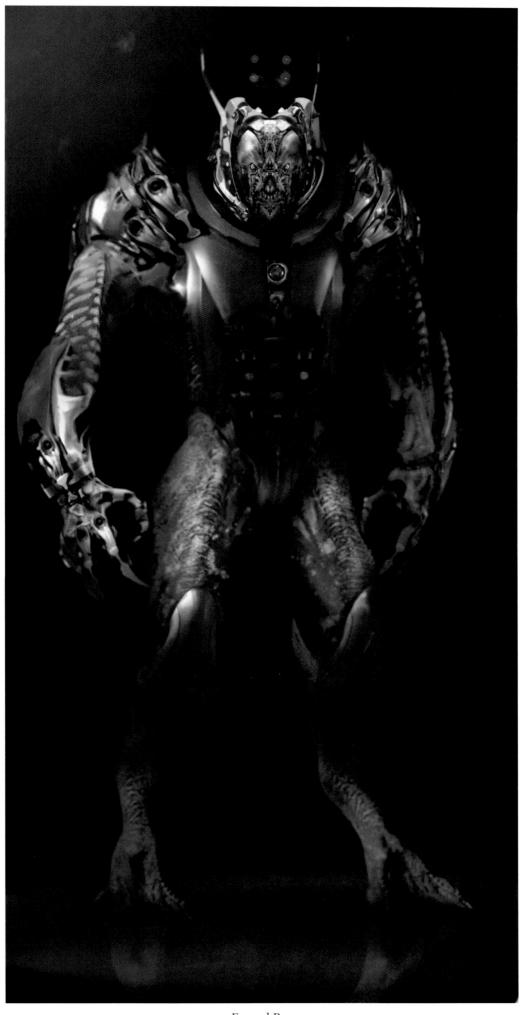

Farond Ray

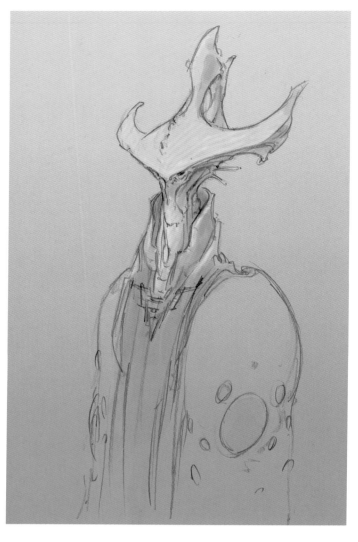

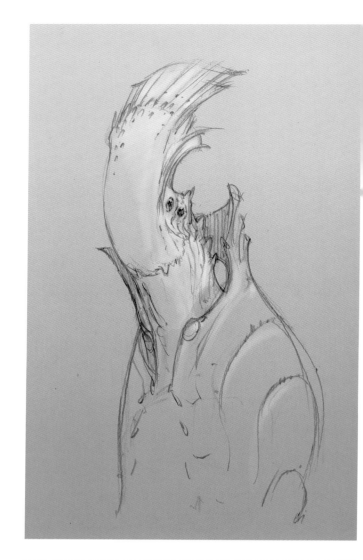

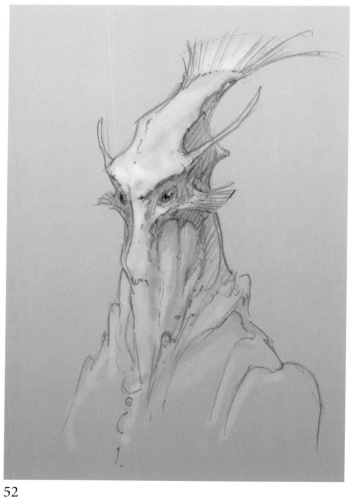

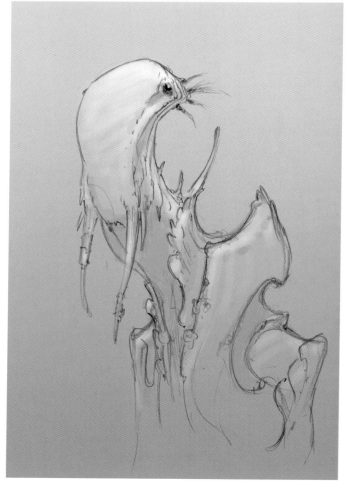

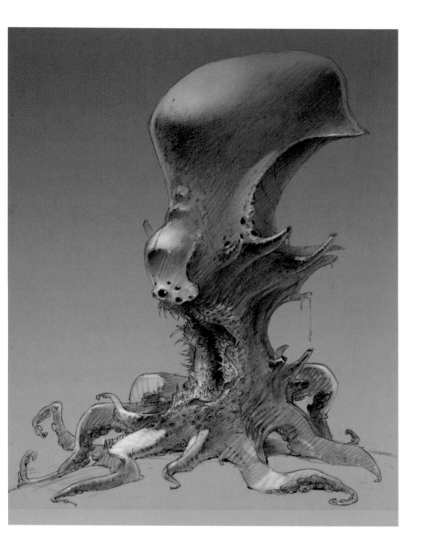

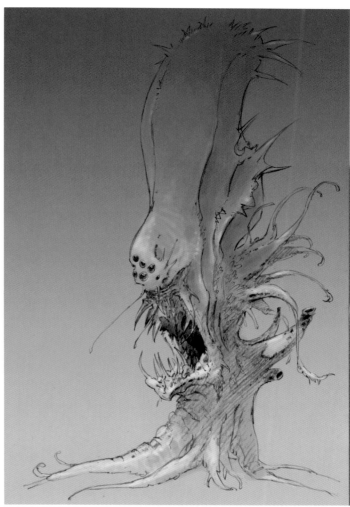

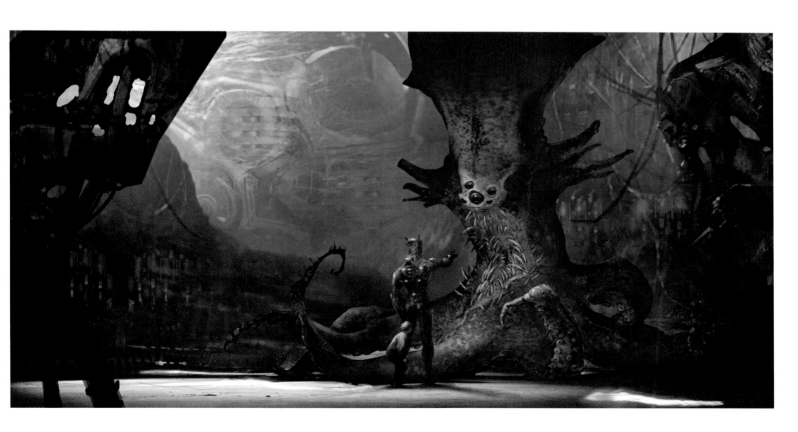

(above) The Brissk Creature

(opposite) Various Humanoid Alien Concepts

53

GULLIVER'S TRAVELS

Gulliver's Travels was a CG film I worked on quite some time ago. I worked a long while on this project which gave me the opportunity to explore the creative process more in depth and think of all the elements of the story as a whole.

Gulliver is a satire that reflects on the society of that period and human nature in general. As a concept artist I always try to have a clear understanding of the intent of the story in order to create visuals that will help enhance the narrative. I enjoy this part of the process but it can also be difficult to keep a consistent language especially when there are so many layers to the production process.

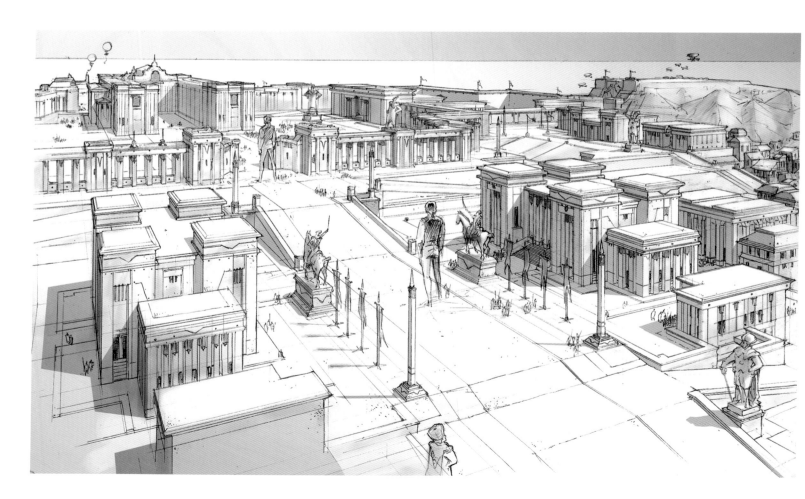

(above) Lilliput Government District and Palace

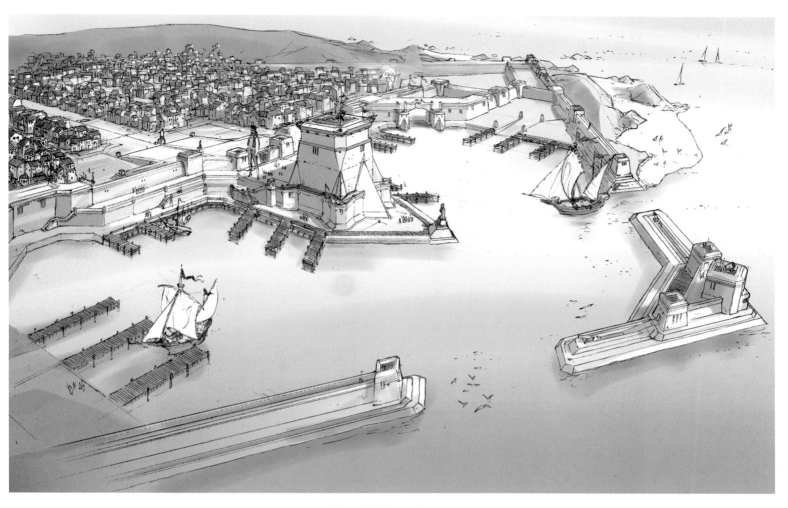

(above) Lilliput Armory
(below) Lilliput Main Street

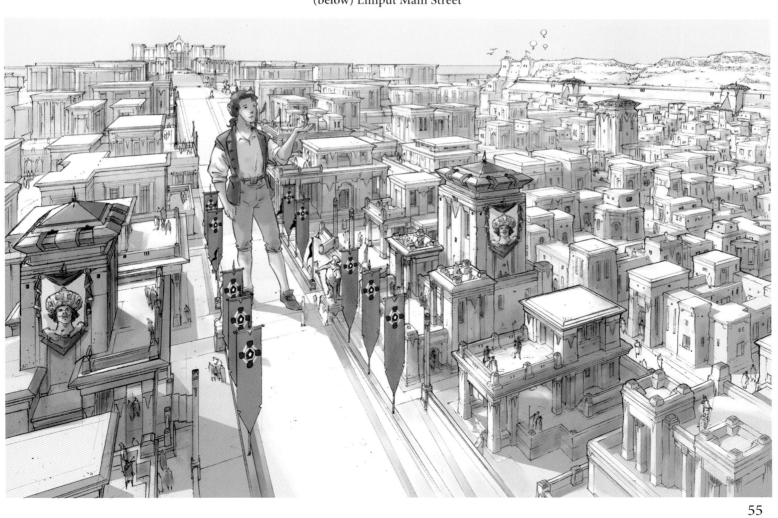

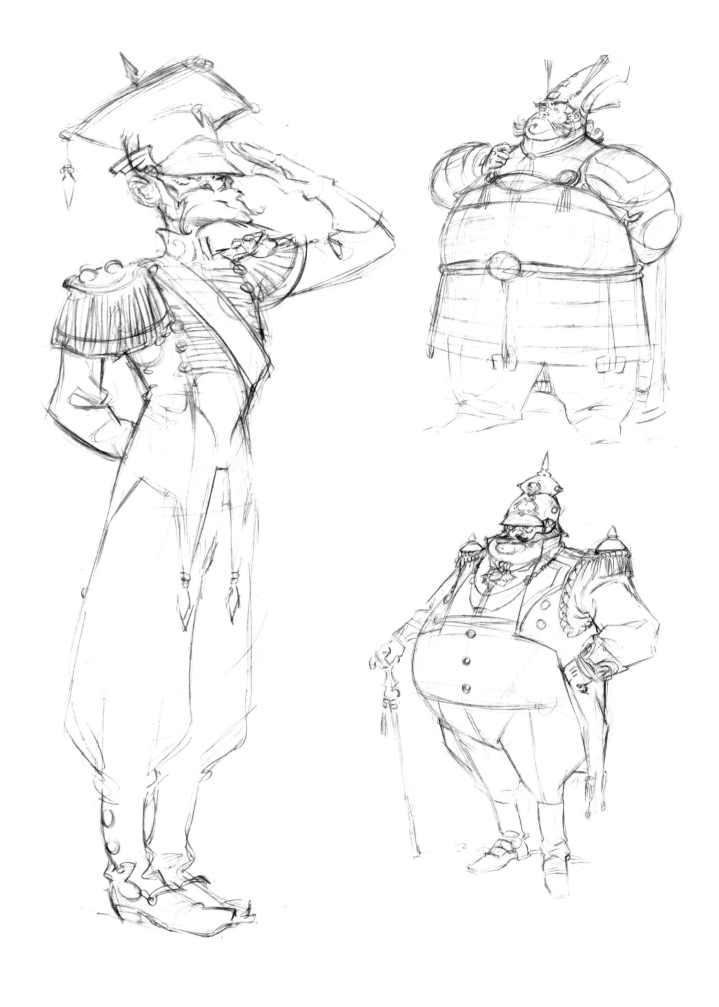

Various Lilliput Military High-Ranking Officers

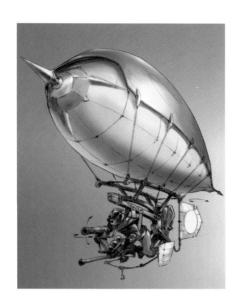

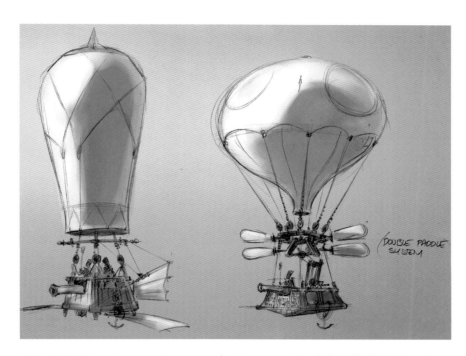

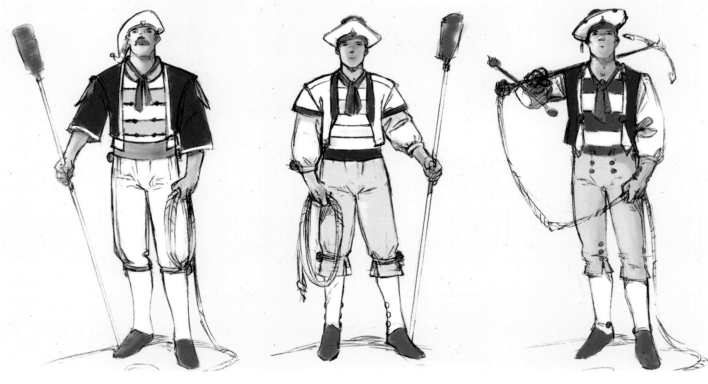

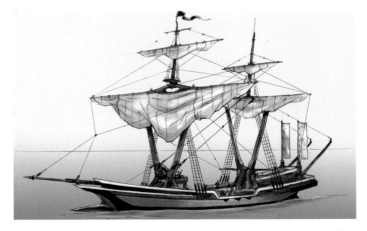

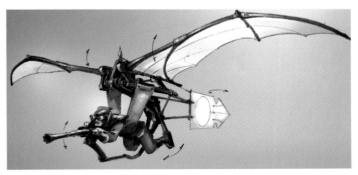

(above) Lilliput Sailors, Battleship, and Airforce

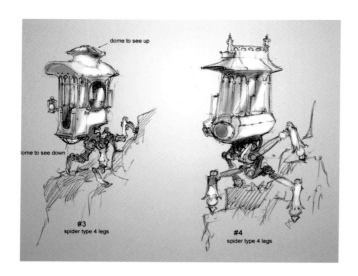

#3
spider type 4 legs

#4
spider type 4 legs

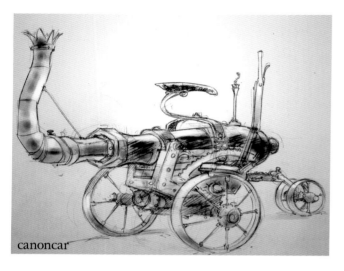

canoncar

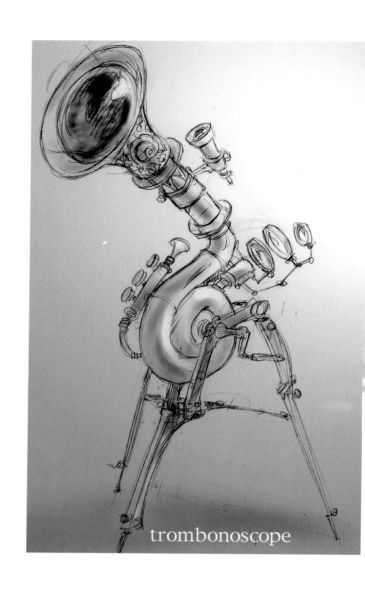

trombonoscope

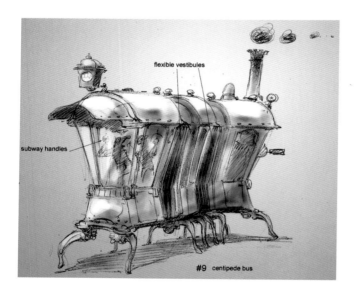

flexible vestibules

subway handles

#9 centipede bus

Laputa Weird Inventions

(opposite) Various Scientists and Inventors

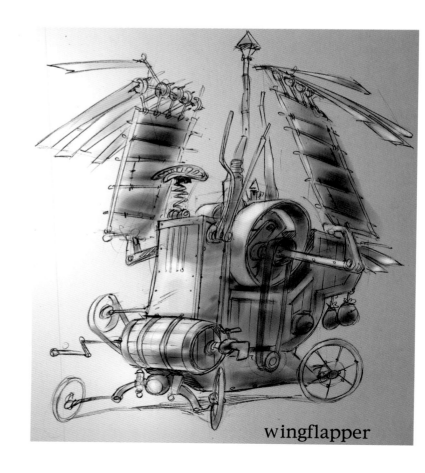

wingflapper

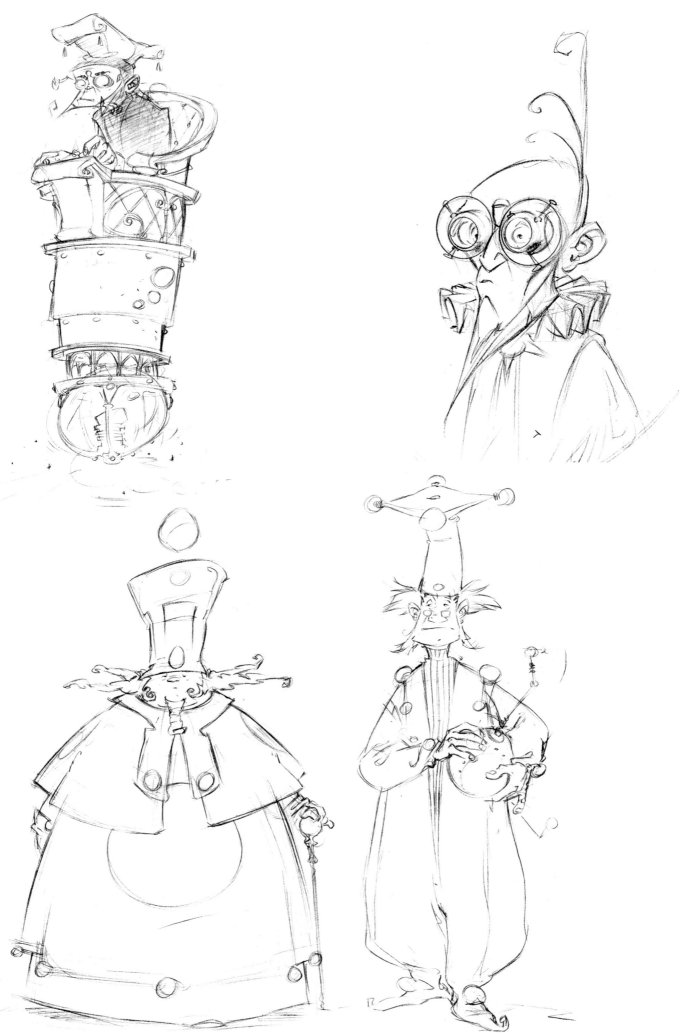

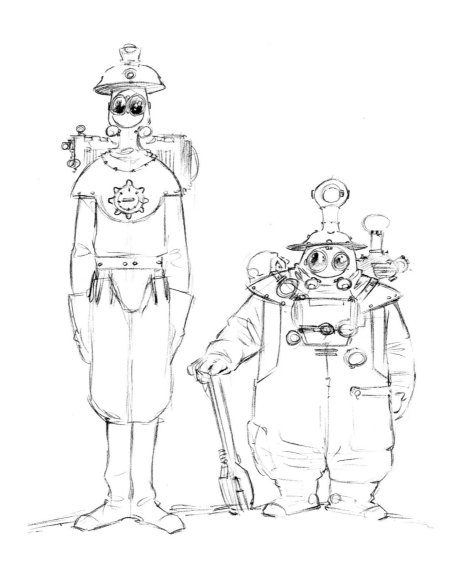

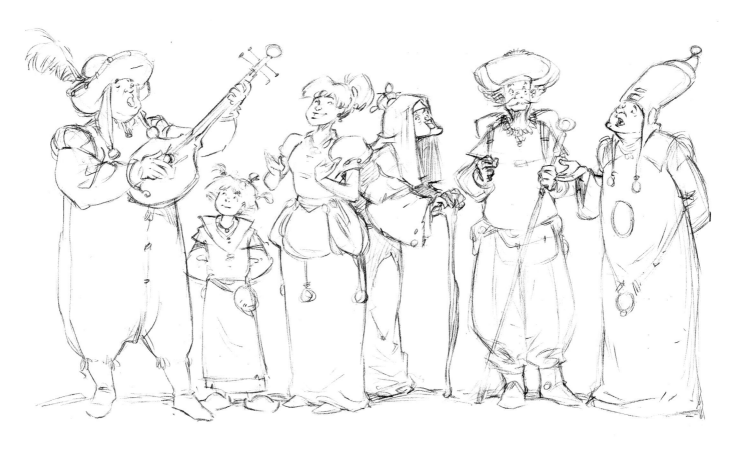

(above) Laputa City Workers and Various Laputa City Dwellers

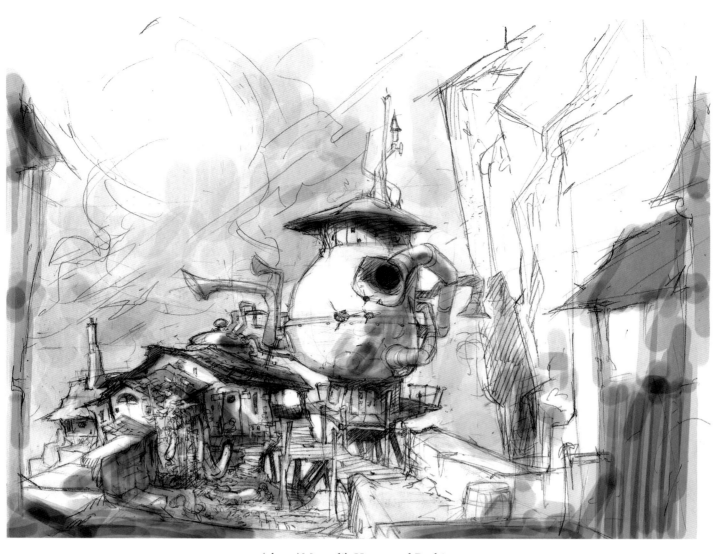

(above) Munodi's House and Beehive
(below) Gulliver's Cage

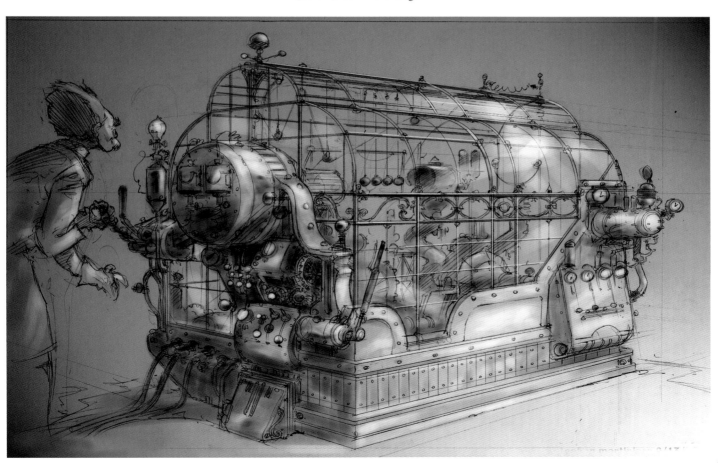

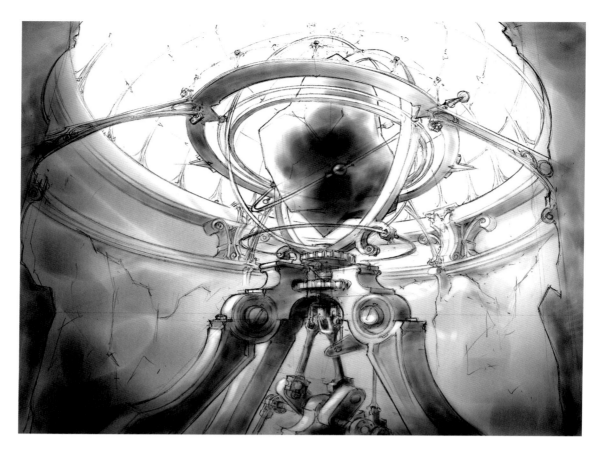

(above) The Load Stone

(below) Munodi Presenting at the Academia

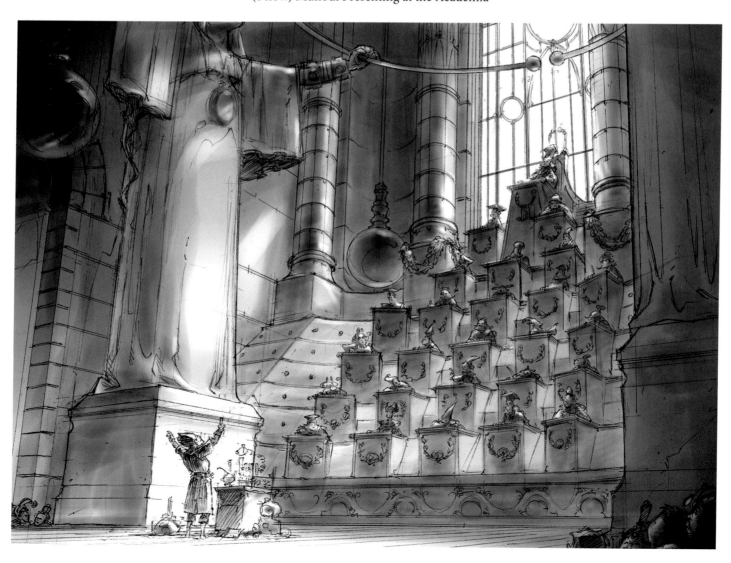

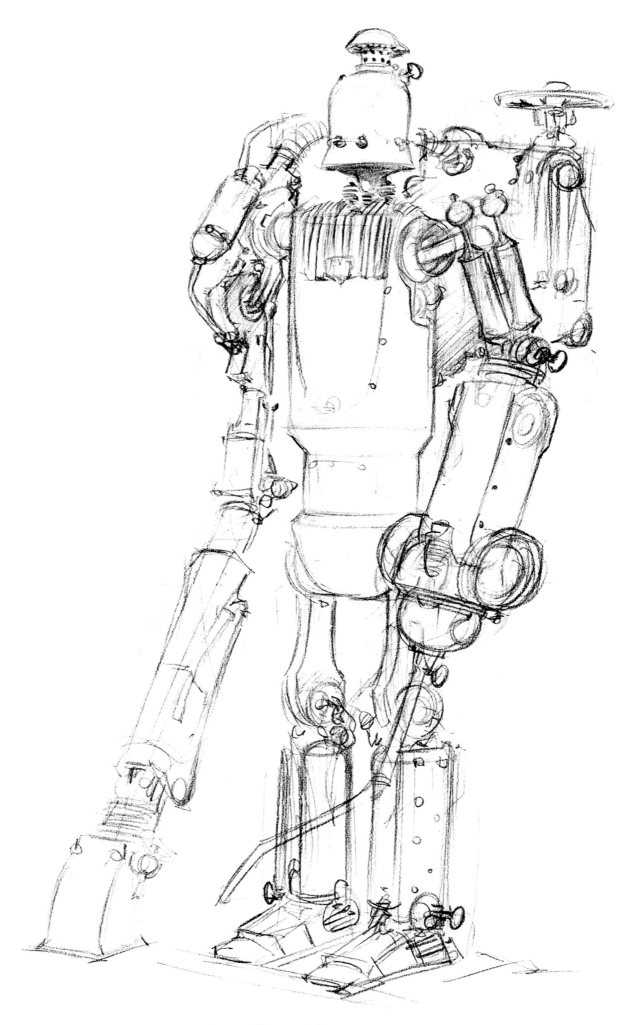

Laputa Cleaning Robot

"When I grow up, I want to be an astronaut."

Stephan Martiniere is an internationally acclaimed Science Fiction and Fantasy artist. In the past 25 years he has become known for his talent, versatility and imagination in every entertainment fields including feature films, animation, video games, theme parks, editorial, commercial and book covers.

His film clients include ILM, Disney, Universal, Paramount, Warner Brothers, 20th Century Fox and Dreamworks. Stephan Martiniere has worked on movies such as *Total Recall 2012*, *Star Wars: Episodes 2-3*, *Tron: Legacy*, *Star Trek*, *Knowing*, *I, Robot*, *The Fifth Element*, *Virus*, *Red Planet*, *The Astronaut's Wife*, *Sphere*, Titan A.E, and *The Time Machine*. Stephan was also the visual design director responsible for the games *URU: Ages beyond Myst*, *URU: The Path of the Shell*, and *Myst 5*. He worked several years as Visual Design Director for the game *Stranglehold* for Midway Games in Chicago and later as Creative Visual Director of the concept department for several other Midway games including *Area 51*, *Blitz*, *Ballers*, *MK vs DC*, *Wheelman*, and several un-announced titles.

Other the last ten years Stephan has produced over a hundred book and comic book covers for such clients as The National Geographic, Tor Books, Pyr, Penguin and Random House. Stephan Martiniere is currently the art director for Rage at ID Software He frequently teaches workshops and presents lectures worldwide and is an advisory board member of the CG society.

From 2006 to 2010, Stephan Martiniere has received the Expose 4 Grand Master Award, nine Expose Excellence Awards, two Expose Master Awards, The Chelsey Award for Best Book Cover, The Spectrum Silver Award for Book Covers, The Hugo Award for Best Professional Artist, The Ennie Award for Best Cover Art, and The Bookgasm Award for Best Cover Artist. In 2009 Stephan was voted one of the 50 Most Inspirational Artists by Imagine FX Magazine.

Velocity is Stephan's third art book, following *Quantum Dreams* (out of print) and *Quantumscapes*.

Contact Stephan Martiniere
Web: http://www.martiniere.com
Email: stephan@martiniere.com
Twitter: @smartiniere